Christo and Jeanne-Claude

The Gates

Central Park, New York City

1979–2005

To stay informed about upcoming TASCHEN titles, please request our magazine at www.taschen.com or write to TASCHEN, Hohenzollernring 53, D–50672 Cologne, Germany, Fax: +49-221-254919. We will be happy to send you a free copy of our magazine which is filled with information about all of our books.

© 2005 TASCHEN GmbH
Hohenzollernring 53, D–50672 Köln
www.taschen.com

© 2005 Christo, New York

© 2005 for the photographs: Wolfgang Volz, Düsseldorf, unless otherwise indicated.

Edited by Simone Philippi, Cologne
Designed by Claudia Frey, Cologne
Production-coordination by Horst Neuzner, Cologne

Printed in Spain
ISBN 3–8228–2805–X
ISBN 3–8228–4242–7 (updated version)

Christo and Jeanne-Claude

The Gates

Central Park, New York City

1979–2005

Photographs by Wolfgang Volz

Introduction by Anne L. Strauss
Picture commentary by Jonathan Henery

TASCHEN

KÖLN LONDON LOS ANGELES MADRID PARIS TOKYO

Christo and Jeanne-Claude:
The Gates, Central Park, New York
Anne L. Strauss

Throughout five decades of collaboration, the husband-and-wife artists Christo and Jeanne-Claude have created highly celebrated public-art projects across the globe. Their forthcoming project *The Gates, Central Park, New York City, 1979–2005* (conceived twenty-five years ago) is their first to be realized in New York City, their home of forty years. This temporary installation is scheduled for completion in Central Park for sixteen days, beginning–weather permitting–on February 12, 2005. It will consist of 7,500 sixteen-foot-tall saffron-colored gates (from six to eighteen feet wide, following the width of each walkway) set up at twelve-foot intervals along twenty-three miles of pedestrian walkways that lace the park. As are all the artists' major temporary projects, *The Gates* is envisioned as an expression of joy and beauty.

The inspiration for the title comes from landscape architects Frederick Law Olmsted and Calvert Vaux, the creators of Central Park, who referred to the openings in the continuous stone wall surrounding the park as "gates."

The project celebrates both the organic beauty and varied topography of Central Park as well as the grid structure of the surrounding city blocks. The saffron color evokes autumnal foliage and was chosen for its striking luminosity when set against a wintry backdrop of leafless trees.

Christo and Jeanne-Claude's aspiration to create a major public work of art for New York began when they emigrated from Europe in 1964. Initially, the artists were most impressed by the city's skyline. They first proposed wrapping two office buildings in lower Manhattan (*Lower Manhattan Wrapped Buildings, Project for #2 Broadway and #20 Exchange Place, New York*) in 1964, but they were denied permission in 1966. Between 1967 and 1968 they submitted proposals for three additional projects in New York (*The Museum of Modern Art, Wrapped, Project for New York City; Wrapped Whitney Museum of American Art, Project for New York City;* and *Wrapped Building, Project for Allied Chemical Tower, Number 1 Times Square, New York City*). They were again denied permission, so that none of these proposals was ever realized. During the 1970s, while creating projects elsewhere but continuing to live and work in New York, the artists remained committed to succeeding in completing a major outdoor work of art in the city. Their attention turned away from the skyline and toward the vast flow of people walking through the streets. The resulting proposal was *The Gates*, a project directly related to the human scale, to be sited in Central Park, whose 843 acres are the ultimate locale for walking at leisure. First proposed in 1979, the project was rejected in 1981 but ultimately approved on January 22, 2003, by Mayor Michael R. Bloomberg, for installation in February 2005.

The Gates is logistically one of the most complicated of the Christos' works to date and will have been the longest in gestation–twenty-six years. It began as their projects all do, with the artists' initial core visual idea, which was examined and developed on paper in preparatory drawings and collages by Christo and then tackled by both artists. It encompasses the essential components of their grand-scale endeavors: years of planning in the evolution of a vision, meetings and public hearings, permits, persuasion, city bureaucracy, engineering studies, wind-tunnel tests, lifesize tests, factory workers. As is consistent with all their projects, the materials will be recycled. *The Gates* will be entirely financed by the artists themselves, through the sale of original drawings, collages, works from the 1950s and 1960s, and lithographs by Christo to museums, private collectors, and art dealers.

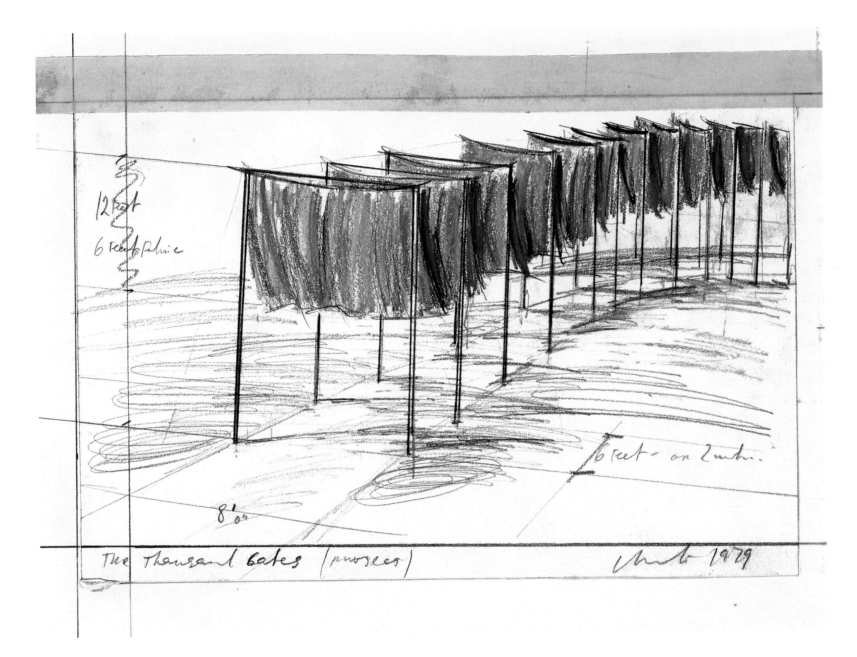

The Thousand Gates, Project

Drawing, 1979
Pencil, charcoal, pastel and tape
28 x 35.5 cm
Collection: The artists, "The Gates, Documentation Exhibition, 1979–2005"
Photo: Eeva-Inkeri

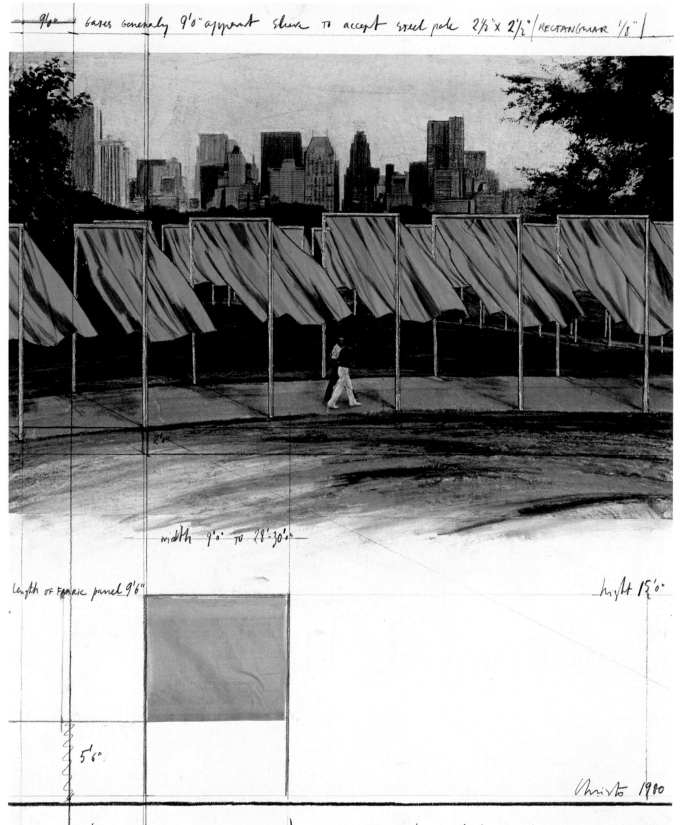

The Gates, Project for Central Park, New York City
Collage, 1980
Pencil, fabric, photograph by Wolfgang Volz, charcoal, wax crayon, fabric sample and pastel
71 x 56 cm
Collection: The artists, "The Gates, Documentation Exhibition, 1979–2005"

hight 15'0" Fabric panel (h. 9'6" x 12"0" + 15%) 12'0" steel pole 3"x3"

15'0

9'0" • between each pale = fabric high less 6"

THE GATES / PROJECT FOR 11.000 Gates IN Central Park, New York City / hight 15'0" X 12'0" or 24' or 39'/

Christo 1980

The Gates, Project for Central Park, New York City
Collage, 1980
Pencil, fabric, photograph by Wolfgang Volz, charcoal, wax crayon and pastel
71 x 56 cm
Collection: The artists, "The Gates, Documentation Exhibition, 1979–2005"

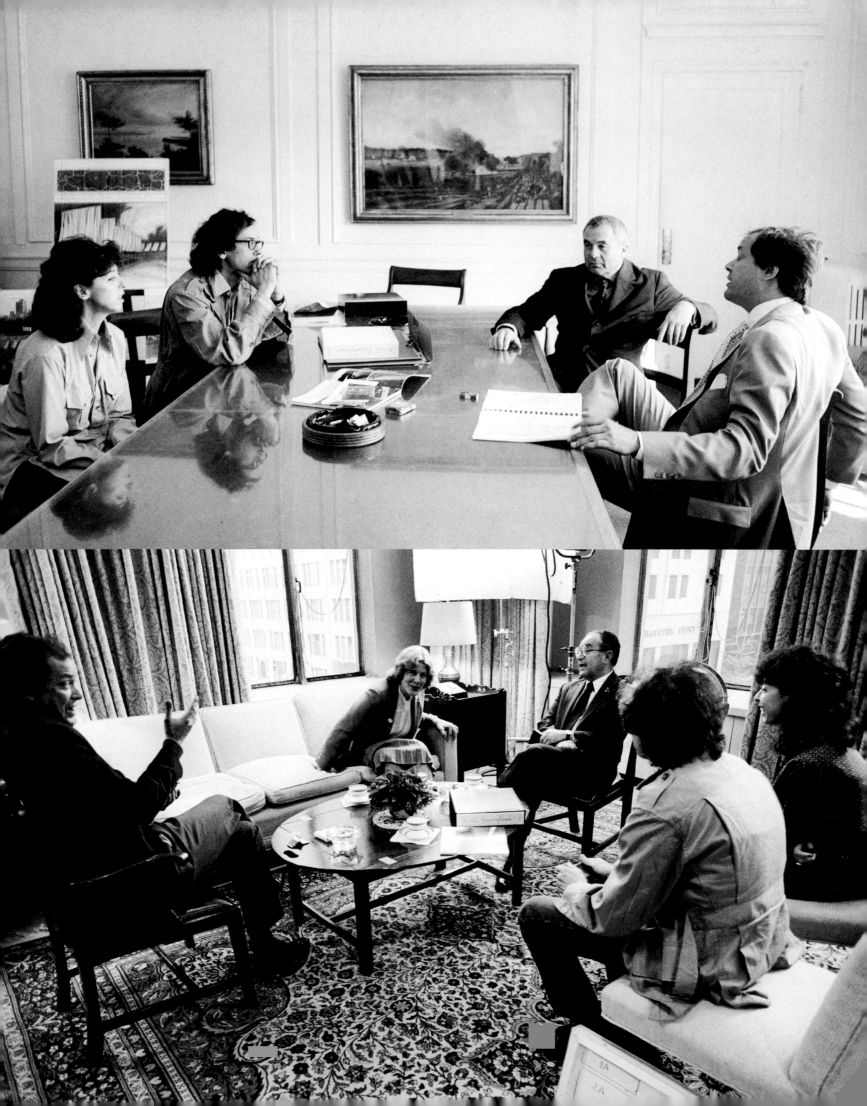

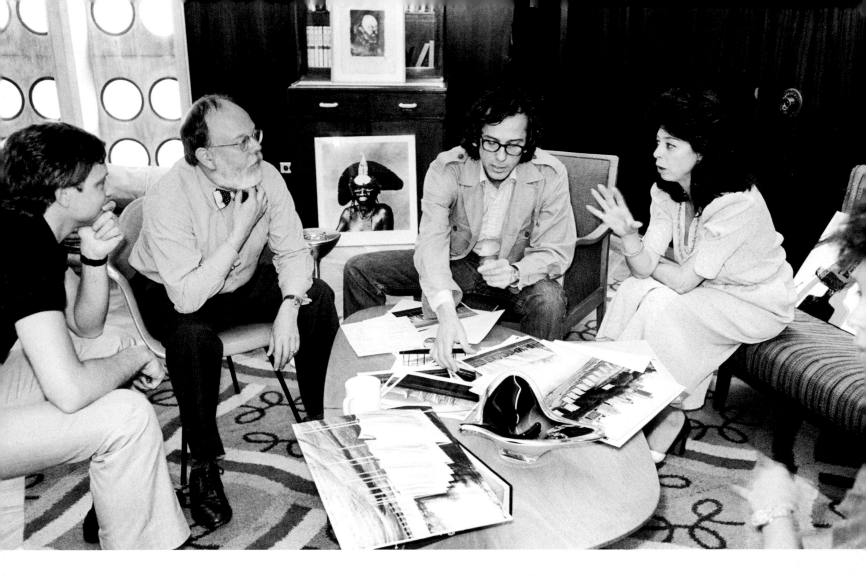

Opposite, top:
On April 22, 1980, Christo, Jeanne-Claude and their attorney Theodore W. Kheel explained *The Gates, Project for Central Park* to the Commissioner of Parks and Recreation of the City of New York, Gordon J. Davis (on the right), at his office in the Central Park Arsenal. The artists brought original drawings and books about some of their realized projects.

On June 9, 1980, Christo and Jeanne-Claude paid a visit to their long-time friend Henry Geldzahler, then the Commissioner of Cultural Affairs (second from the left) and former Curator of 20th Century Art at the Metropolitan Museum. He and his assistant Randall Bourscheidt tried to find ways to help the artists in New York City's tightrope exercise in negotiations.

Opposite:
Christo and Jeanne-Claude (on the right), and Gordon J. Davis (left) at a meeting organized by Agnes Gund, a prominent art collector (seated on the couch) and Martin Segal, then president of Lincoln Center and friend of the arts, in his office on April 29, 1980.

Jeanne Claude, Christo and Theodore L. Dougherty took walks in Central Park during the summer of 1980. Ted was the builder contractor/engineer who built *Valley Curtain, Rifle, Colorado, 1970-72*; *Running Fence, Sonoma* and *Marin Counties, California, 1972–76*; and *Surrounded Islands, Biscayne Bay, Greater Miami, Florida, 1980–83*. Ted's ailing health forced him to delegate some of the work to other contractors but he still worked with them at the *Wrapped Walk Ways, Kansas City Missouri 1977–78; The Pont Neuf Wrapped, Paris, 1975–85; The Umbrellas, Japan – USA, 1984–91* and *Wrapped Reichstag, Berlin, 1971–95*. Theodore Dougherty died on May 14, 1993.

Opposite, top:
February 1981, presentation to the members of Community Board number 10, (between Central Park North, 162nd Street and the Harlem River). The board voted unanimously in support of *The Gates*.

Opposite:
Starting in January 1981, many seminars were conducted at the office of Dr. Kenneth Clark in order to prepare the Human Impact Study about *The Gates*. During those seminars, Christo and Jeanne-Claude were sometimes present to answer questions, but often Dr. Clark did not request them to attend, sensing that the audience tended to be freer in their questions without the presence of the artists.

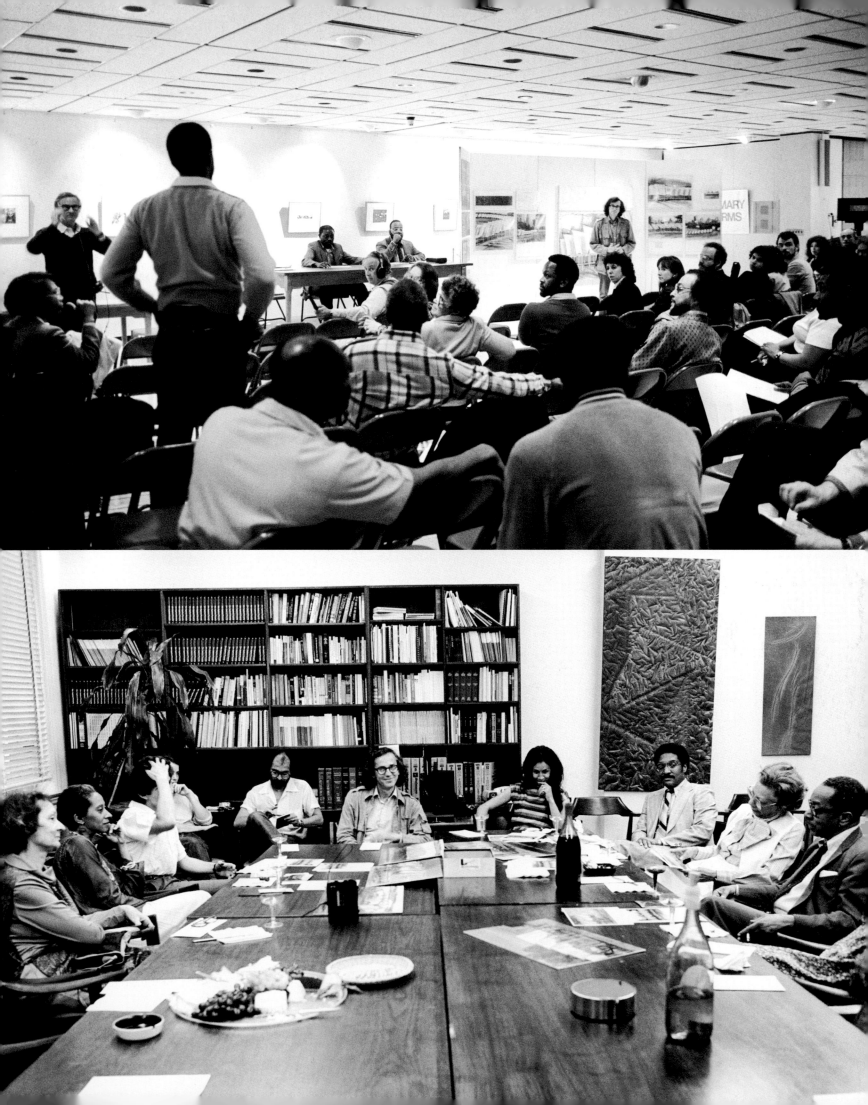

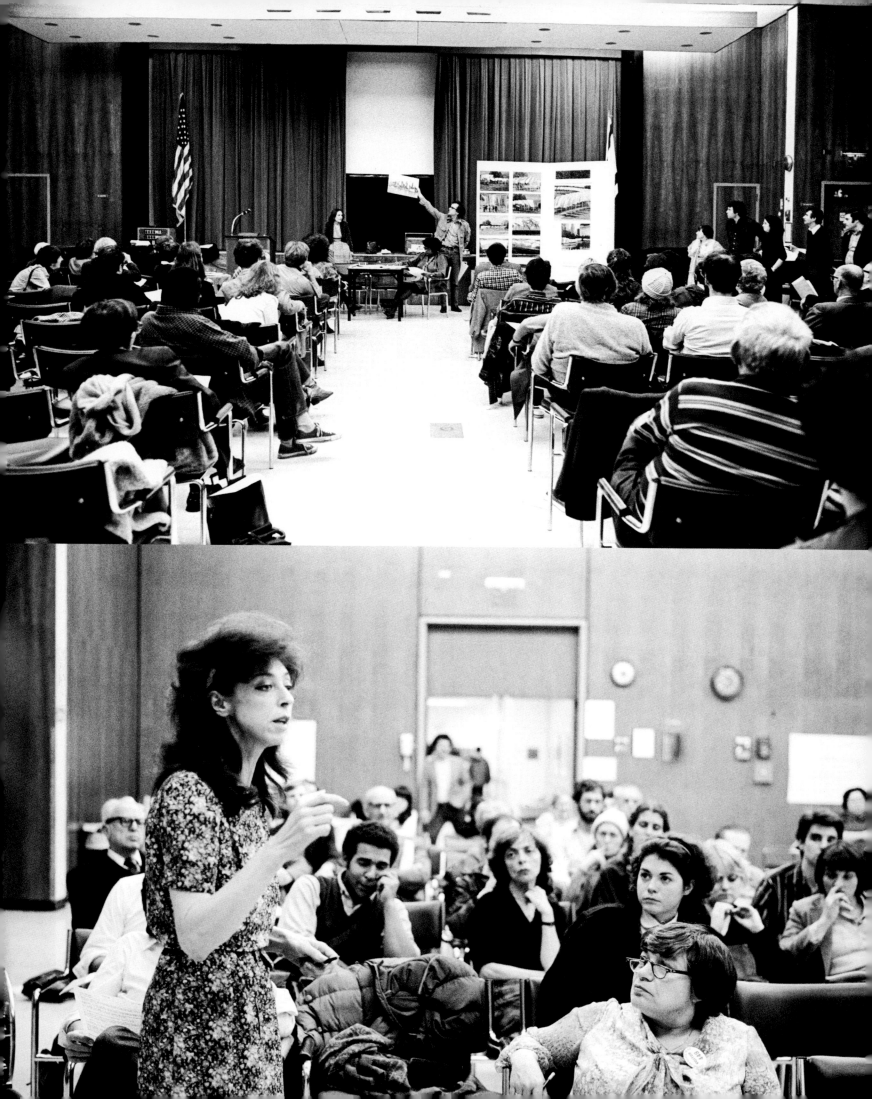

In 1980, *The Gates* were just starting. The height was at first 12 feet (3.65 m), then 15 feet (4.57 m), and now 16 feet (4.87 m). The poles were made of steel and were 2.5 inches (6.35 cm) wide, while they are now made of vinyl, 5 inch by 5 inch (12.7 x 12.7 cm) wide. The number of Gates was estimated at 11,000 to 15,000 by adding the total length of the walkways without considering the low branches above the walkways. The measuring wheel remained in Christo's studio for 21 years.

In February 1981, the permit for *The Gates, Project for Central Park, New York City* was refused by the Commissioner of Parks and Recreation.

The Gates, Project for Central Park, New York City Drawing, 1980, Pencil and charcoal, 106.6 x 165 cm
Collection: The artists, "The Gates, Documentation Exhibition, 1979–2005"

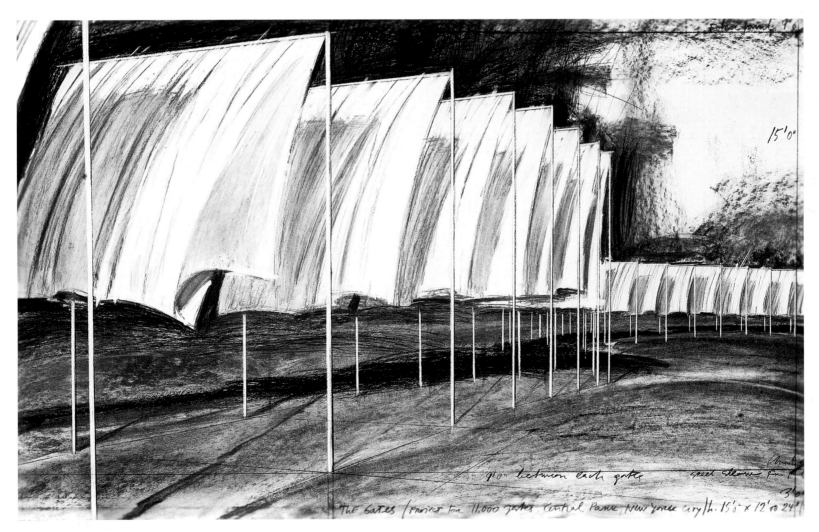

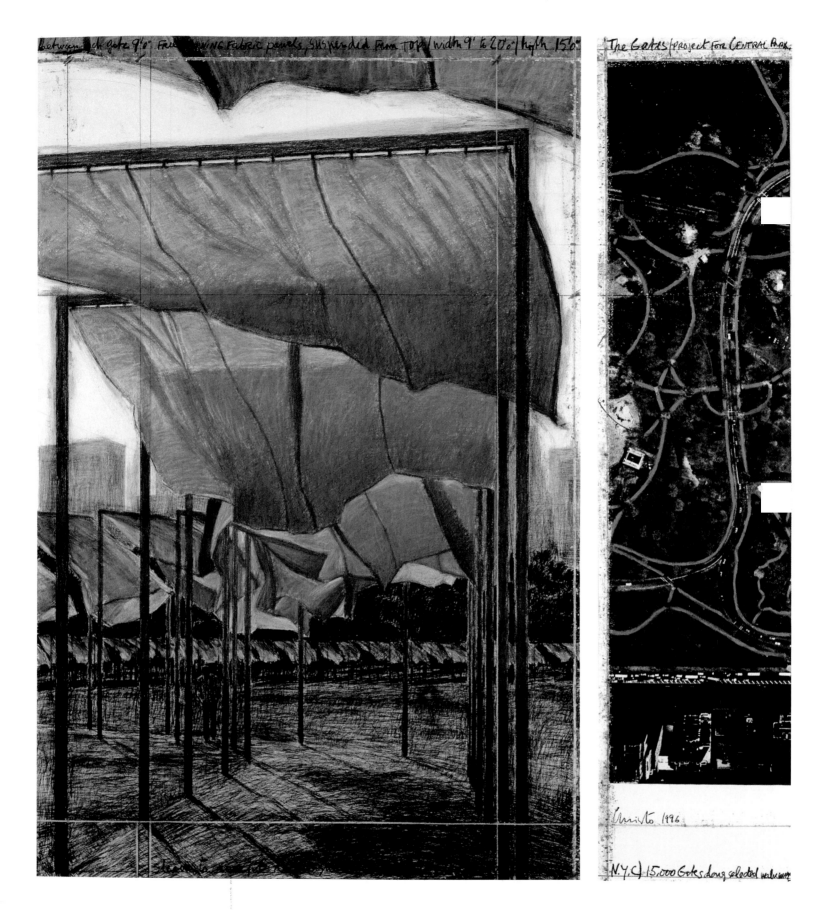

The Gates, Project for Central Park, New York City
Drawing, 1996
Pencil, charcoal, pastel, wax crayon and aerial photograph
In two parts: 165 x 106.6 cm and 165 x 38 cm
Collection: The artists, "The Gates, Documentation Exhibition, 1979–2005"

The Gates, Project for Central Park, New York City
Drawing, 1991
Pencil, charcoal, pastel, wax crayon and map
In two parts: 219.7 x 38 cm and 219.7 x 106.6 cm
Collection: The artists, "The Gates, Documentation Exhibition, 1979–2005"

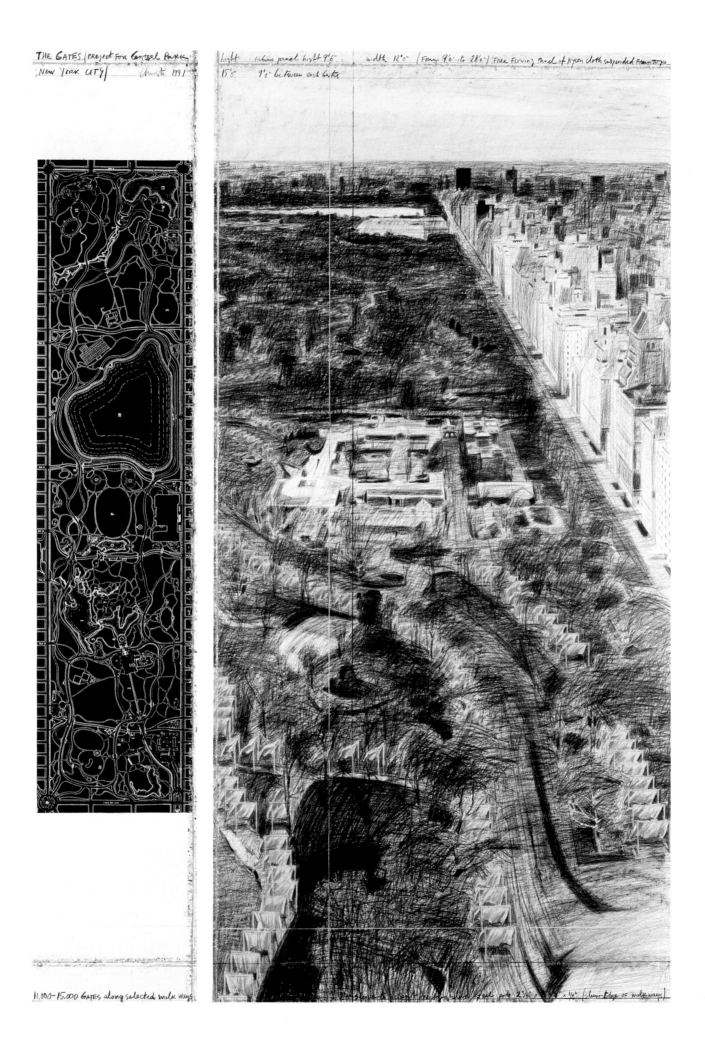

THE GATES (Project For Central Park, New York City) Christo 1991

light future panel height 9'6" width 12'0" (From 9'0" to 28'0") Free Flowing Panel of Nylon cloth suspended From tops

15'0" 9'0" between each Gates

11,000–15,000 Gates along selected walk ways light future panel height 9'6" width 12'0" (From 9'0" to 28'0") Free Flowing panel of Nylon cloth suspended of walk ways

15'0" 9'0" between each Gates

15

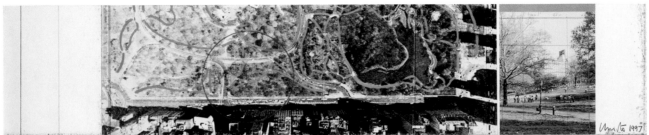

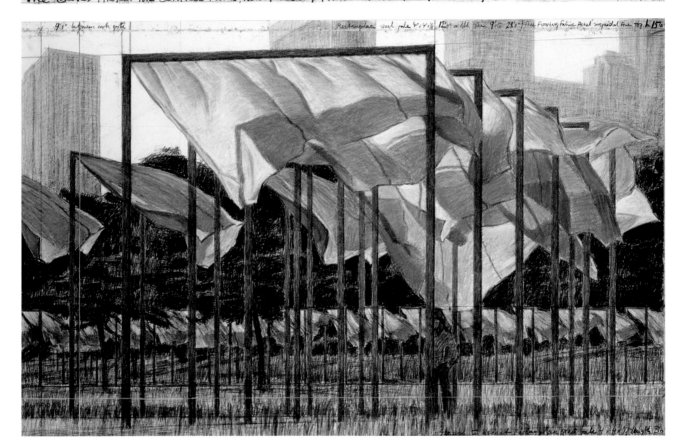

The Gates, Project for Central Park, New York City
Drawing, 1997
Pencil, charcoal, pastel, photograph by Wolfgang Volz, wax crayon, aerial map and tape
In two parts: 38 x 165 cm and 106.6 x 165 cm
Collection National Gallery, Washington D.C. Gift of Herbert and Dorothy Vogel

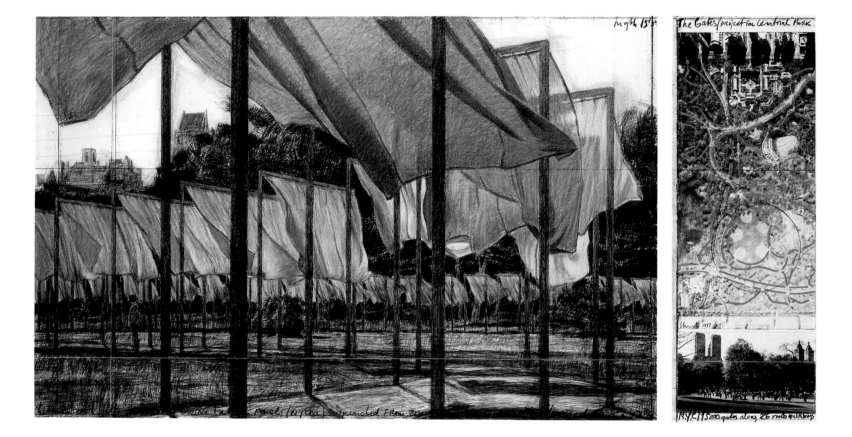

The Gates, Project for Central Park, New York City
Drawing, 1997
Pencil, charcoal, pastel, photograph by Wolfgang Volz, wax crayon and aerial map
In two parts: 106.6 x 165 cm and 106.6 x 38 cm
Private collection, Sweden

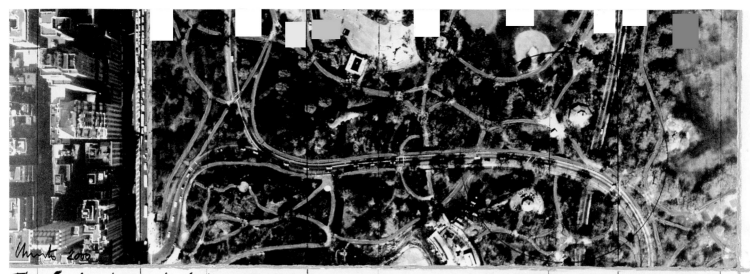

The Gates (Project for Central Park, New York City) Central Park So, 5th Ave, Central Park W., Cathedral Pkwy, W 110 St.

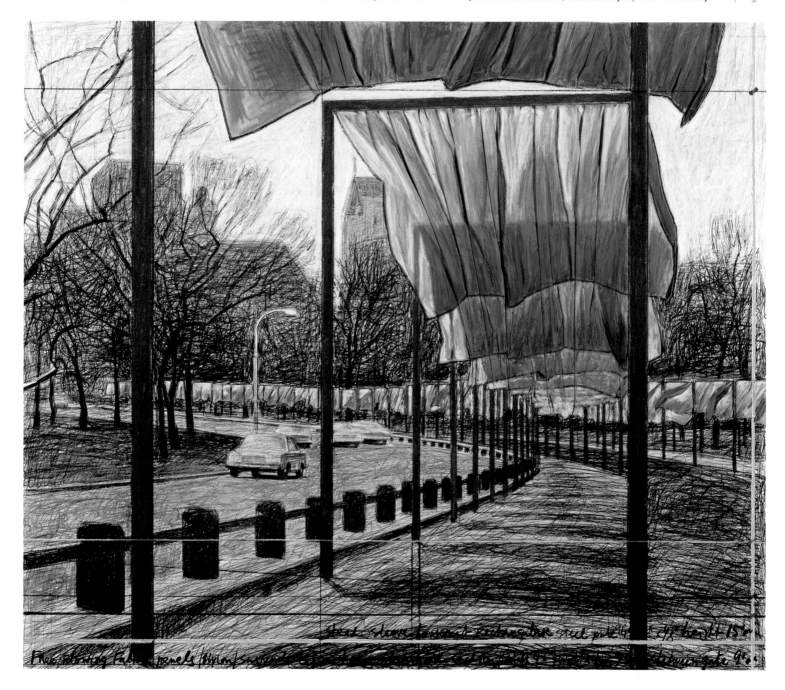

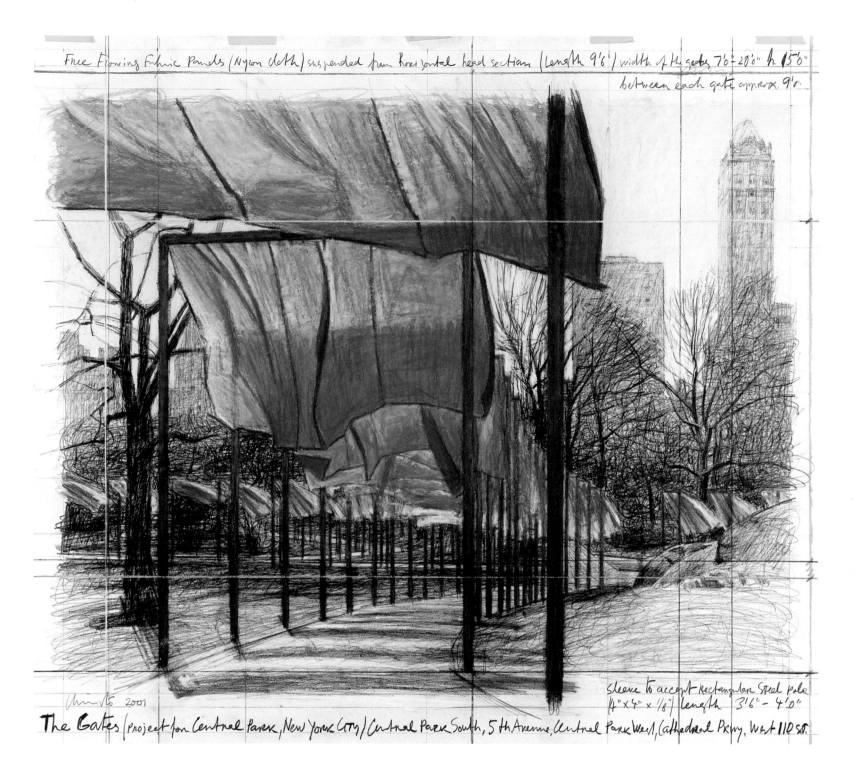

Free Flowing Fabric Panels (Nylon cloth) suspended from horizontal head section (Length 9'6') width of the gates 7'6"-20'0" h. 15'6"

between each gate approx. 9'0.

Sleeve to accept rectangular Steel pole (4"x4" x 1/8") length 3'6" - 4'0"

The Gates (Project for Central Park, New York City) Central Park South, 5th Avenue, Central Park West, Cathedral Pkwy, West 110 St.

The Gates, Project for Central Park, New York City

Collage, 2000

Pencil, fabric, charcoal, pastel, wax crayon and aerial photograph

In two parts: 30.5 x 77.5 cm and 66.7 x 77.5 cm

Collection: The artists, "The Gates, Documentation Exhibition, 1979–2005"

The Gates, Project for Central Park, New York City

Drawing, 2001

Pencil, charcoal, pastel, wax crayon and tape

70.5 x 77.5 cm

Private collection, New York

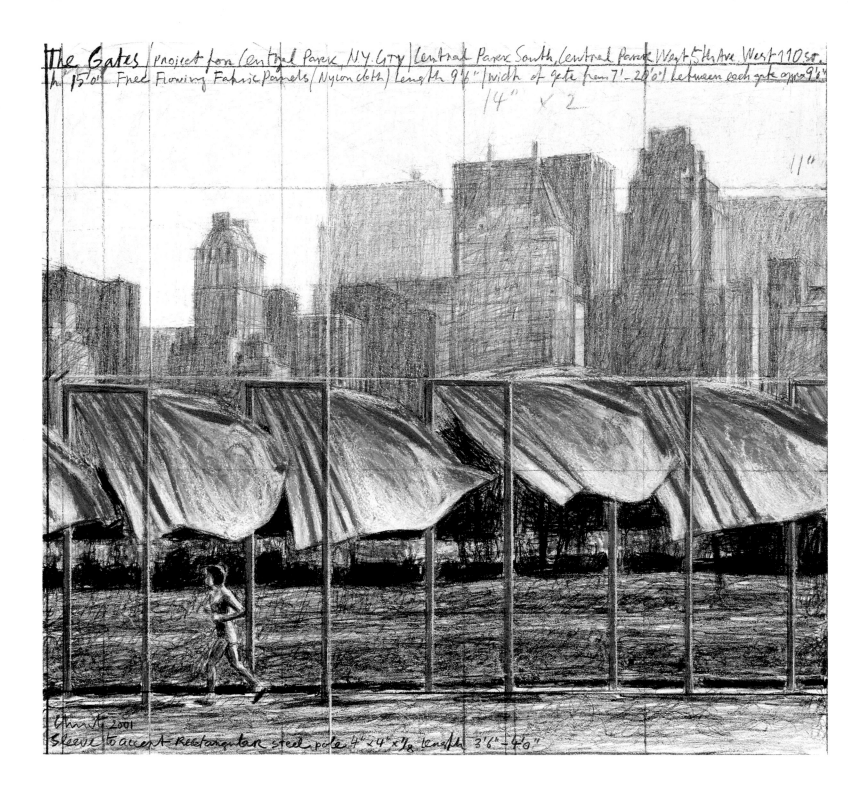

The Gates, Project for Central Park, New York City

Drawing, 2001

Pencil, charcoal, pastel and wax crayon

35.2 x 38.7 cm

Private collection, Germany

The Gates (project for Central Park
New York CITY) 11000 steel gates
along 26 miles of selected walkways

Central Park South, 5th. Avenue, Columbus
Circle, Central Park West, Cathedral
PKWY and West 110th. Street

Free Flowing Fabric panels / Nylon Cloth / suspended from horizontal head section / length 9' / width of gate two 7'6"-20'
between each gate approximately 9'-12'0"

height 15'0"

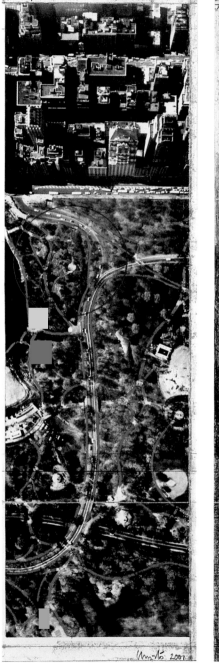
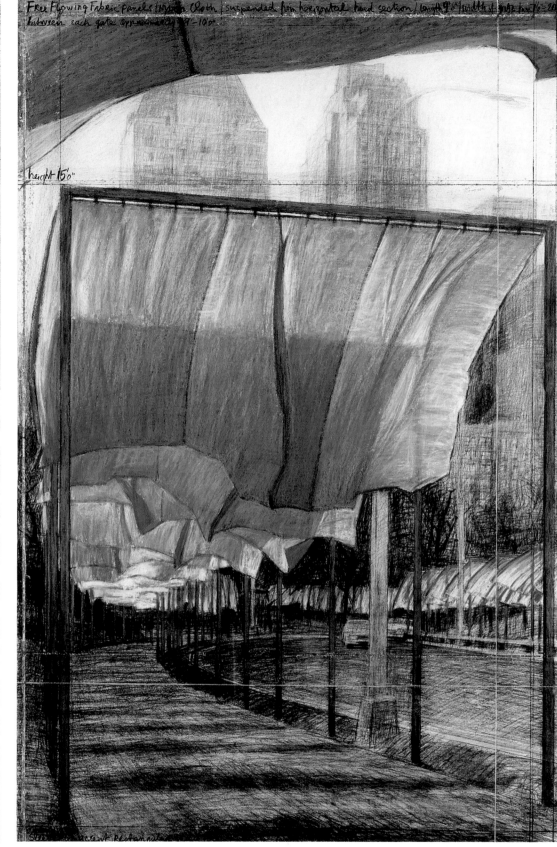

The Gates, Project for Central Park, New York City
Drawing, 2001
Pencil, charcoal, pastel, wax crayon and aerial photograph
In two parts: 165 x 38 cm and 165 x 106.6 cm
Private collection, Sweden

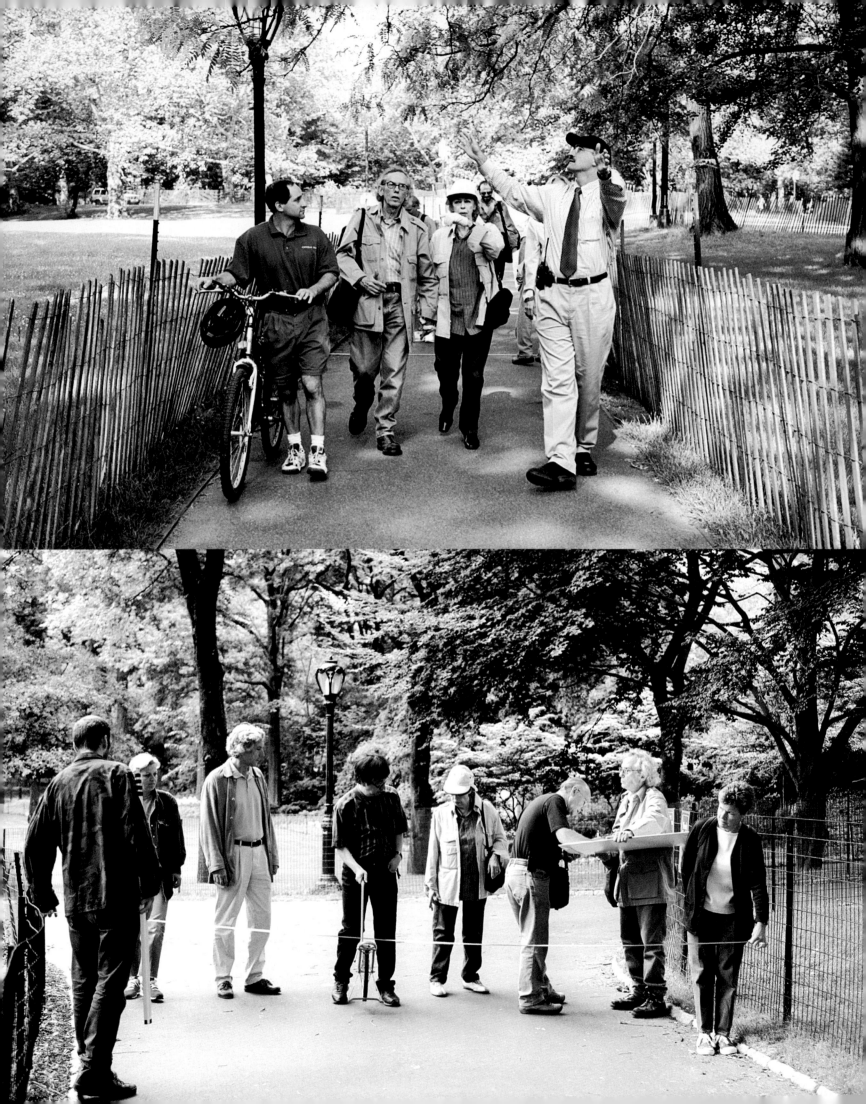

Opposite:

In June 2002, Adam Kaufman, Central Park Director of Night and Weekend Operations (on the left) and Douglas Blonsky, Central Park Administrator (on the right) showed Christo and Jeanne-Claude the many low branches above the walkways, where the 16-feet (4.87 m) tall Gates cannot fit on that portion of the walkway.

Opposite:

Vladimir Yavachev (far left), son of Christo's elder brother and project assistant since 1991, and Jonita Davenport (far right), a team member since 1990 and project director of *The Gates*, measure the width of a walkway. Between them are Sylvia Volz (wife of photographer Wolfgang Volz), Simon Chaput (team member since 1985), art historian and author Masa Yanagi (team member since 1983) holding the distance wheel, and Jeanne-Claude, while Vince Davenport and Christo mark the measurements on a map.

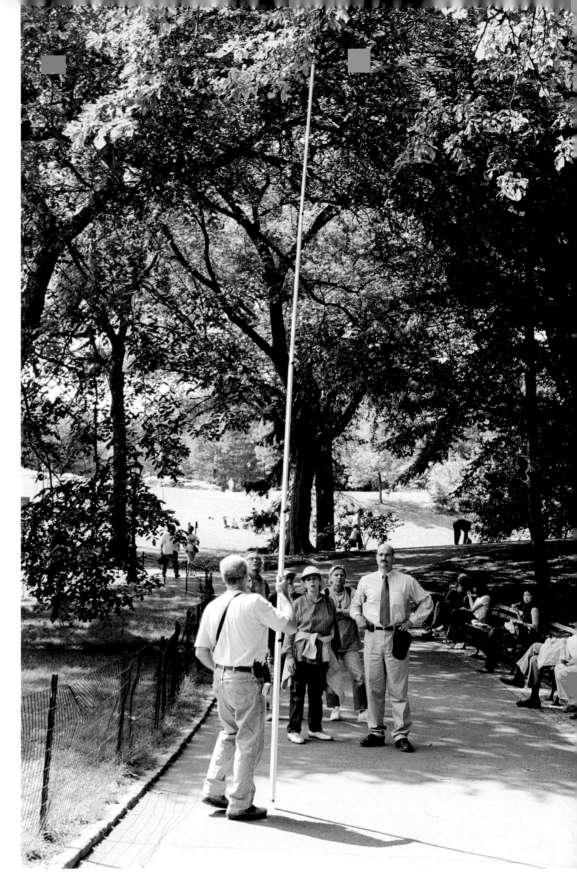

Project engineer and director of construction Vince Davenport measures the height of one of the many low branches in Central Park, with Christo, Jeanne-Claude, Sylvia Volz and Central Park administrator Douglas Blonsky, in June 2002.

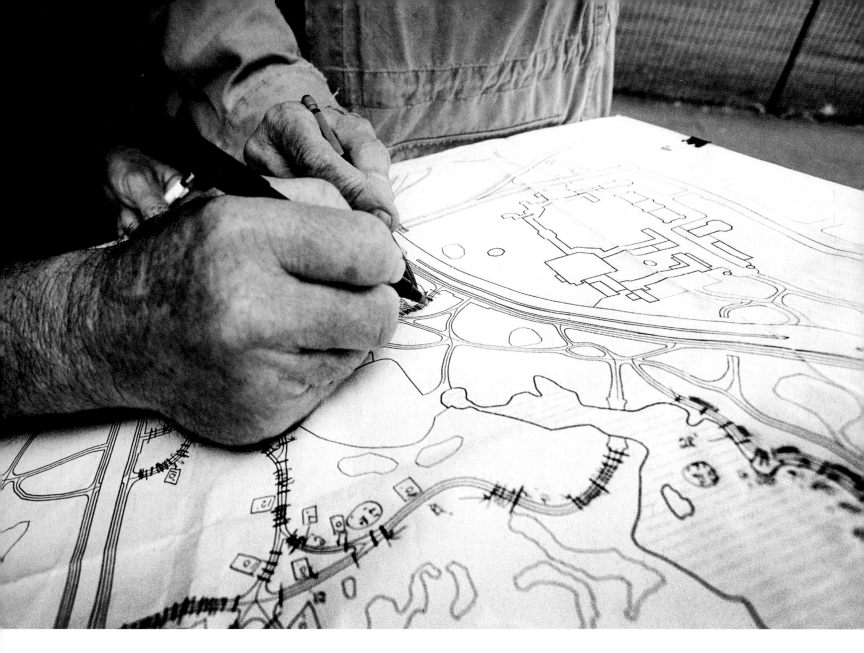

Vince Davenport and Christo mark the location of some of the 7,500 gates on a map provided by the Central Park administrator. This work took three weeks and involved walking one hundred miles (160 km) in Central Park during June 2002.

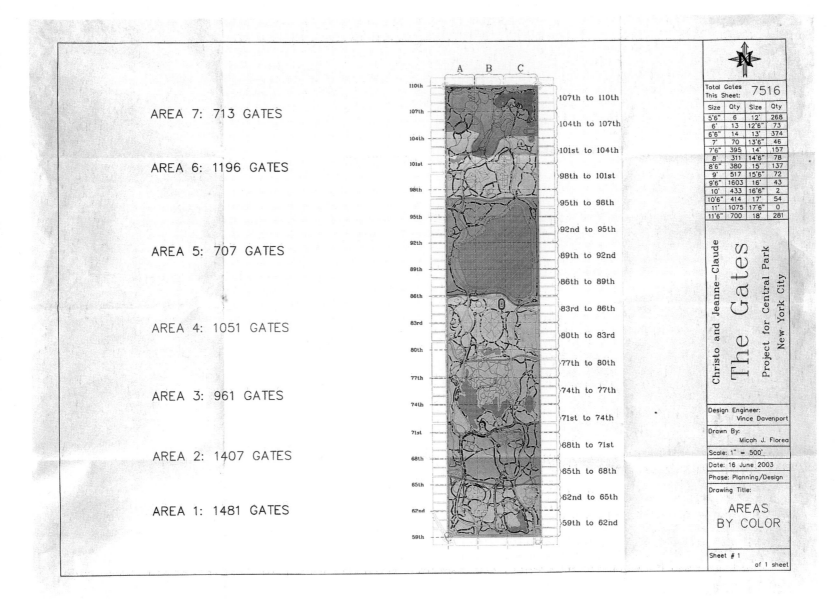

Map of the seven work areas in Central Park
91.44 x 121.9 cm
Drawn by Micah J. Florea
Design Engineer: Vince Davenport
Scale: 1 inch = 500 feet (1 cm = 60 meters)

Vince Davenport divided Central Park into seven work areas,
which are further divided into 73 sections.

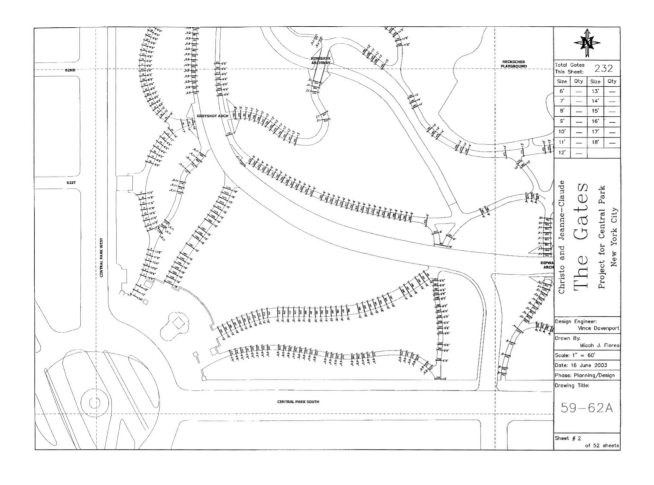

The position of *The Gates* is indicated on 52 engineering maps. The numbers next to each gate show: the area number, the number of that specific gate and its width. The blank areas indicate low branches above the walkways, where gates cannot be installed. When low branches do not interfere, *The Gates* will be placed at 12 foot (3.65 m) intervals.

Gates locations,
Sheet # 2 of 52.

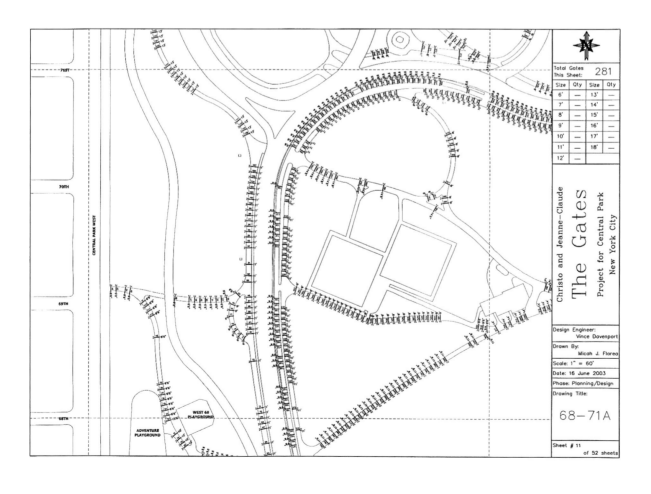

Gates locations,
Sheet # 11 of 52.

Sheets # 2, 5, 11, 52

45.7 x 60.9 cm
Drawn by Micah J. Florea
Design Engineer:
Vince Davenport
Scale: 1 inch = 60 feet
(1 cm = 7.2 meters)

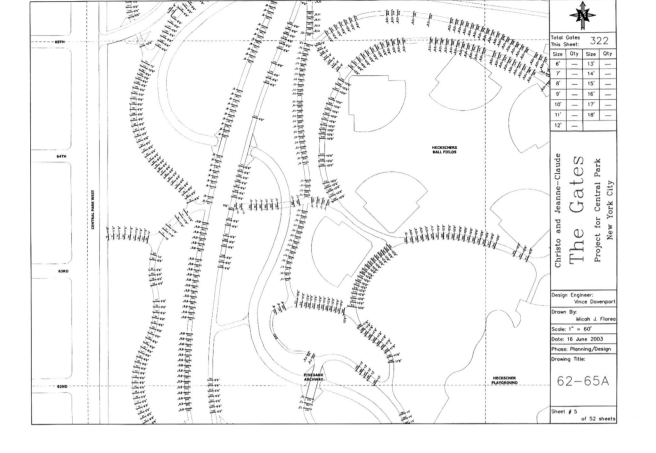

Gates locations,
Sheet # 5 of 52.

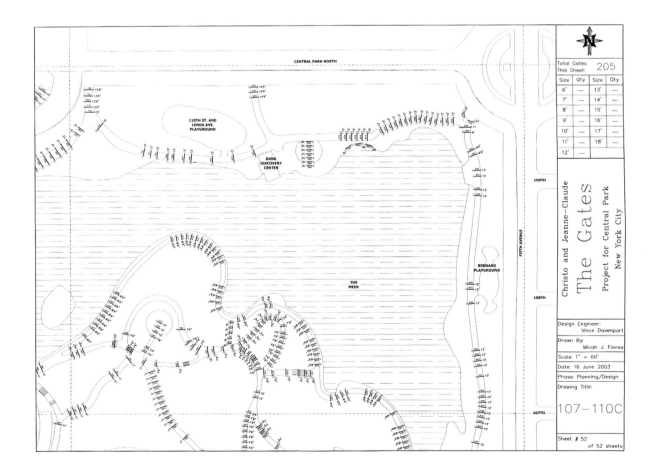

Gates locations,
Sheet # 52 of 52.

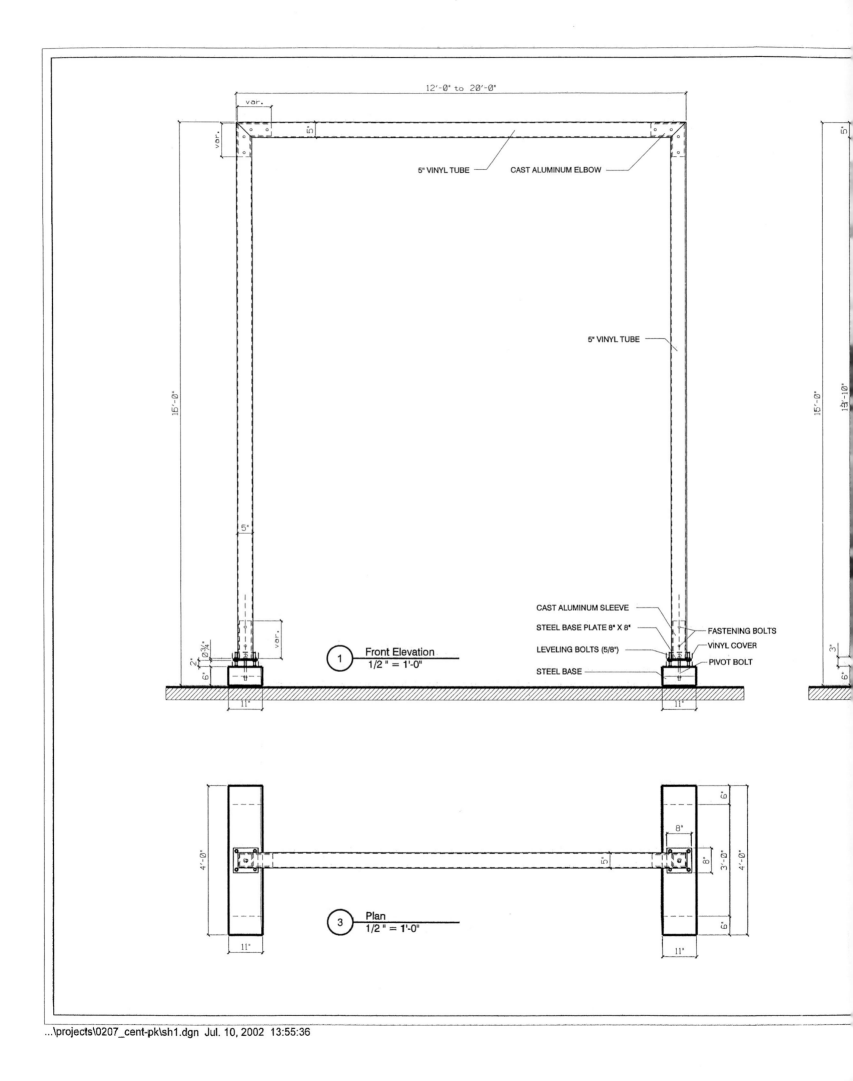

12'-0" to 20'-0"

var.

5"

5" VINYL TUBE CAST ALUMINUM ELBOW

var.

var.

5" VINYL TUBE

15'-0"

15'-0"

13'-10"

5"

CAST ALUMINUM SLEEVE

STEEL BASE PLATE 8" X 8" FASTENING BOLTS

LEVELING BOLTS (5/8") VINYL COVER

STEEL BASE PIVOT BOLT

Ø3/4"

var.

2"

6"

3"

6"

① Front Elevation
1/2 " = 1'-0"

11"

11"

4'-0"

6"

8"

8"

3'-0"

4'-0"

5"

6"

③ Plan
1/2 " = 1'-0"

11"

11"

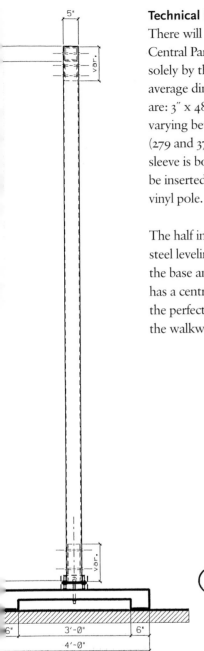

Technical Engineering Drawings

There will be no holes in the ground in Central Park. The vinyl poles are supported solely by the weight of the steel bases. The average dimensions of the solid steel bases are: 3″ x 48″ x 12″ (7.6 x 121.9 x 30.4 cm) varying between 614 and 835 pounds (279 and 370 kilograms) each. A base anchor sleeve is bolted to the leveling plate and will be inserted into and bolted to the vertical vinyl pole.

The half inch thick, 8″ x 8″ (20.3 x 20.3 cm) steel leveling plate will be secured between the base anchor sleeve and the steel base. It has a central pivoting bolt, which will ensure the perfect verticality of the poles, even when the walkways are inclined.

② Side Elevation
1/2 ″ = 1'-0″

Revisions		
No.	Descriptions	Date

The Gates
Project for Central Park

PLAN + ELEVATIONS

Job No.:	0207
Date:	6/18/02
Scale:	1/2 ″=1'-0″
Drawn:	ES
Checked:	
Approved:	

Design and Engineering:

Vince Davenport

A1.0

CVJ, Corp. New York

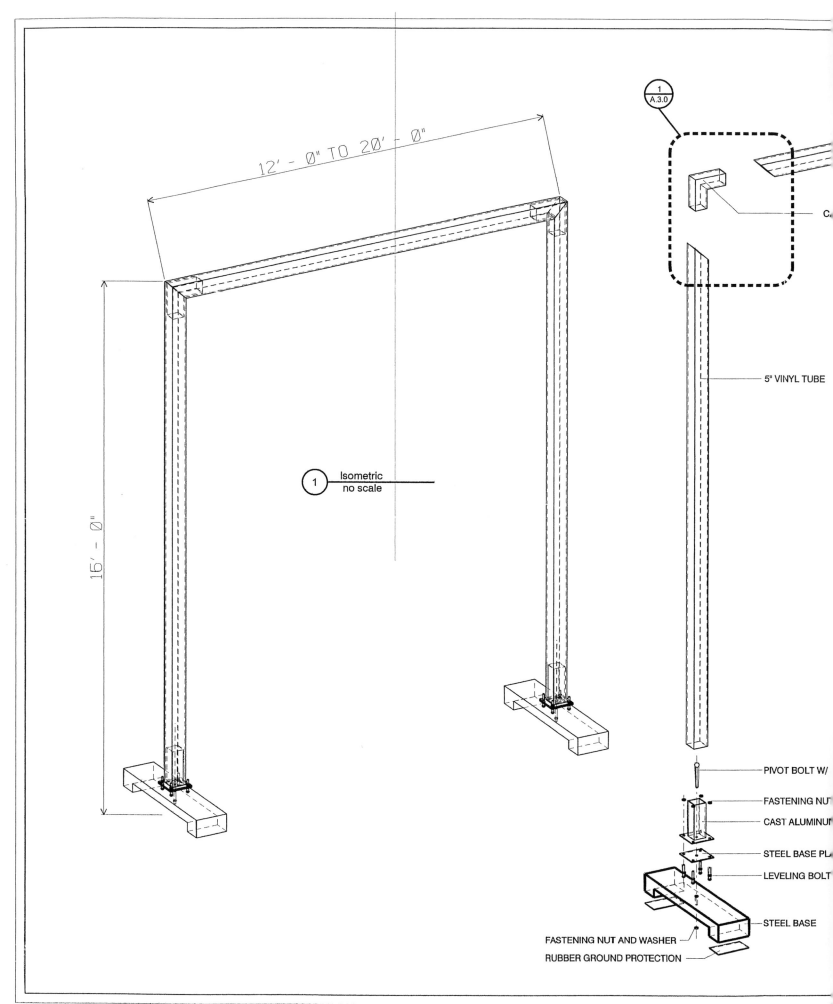

12' - 0" TO 20' - 0"

16' - 0"

1 Isometric
 no scale

1
A.3.0

C,

5" VINYL TUBE

PIVOT BOLT W/

FASTENING NUT

CAST ALUMINUM

STEEL BASE PL

LEVELING BOLT

STEEL BASE

FASTENING NUT AND WASHER

RUBBER GROUND PROTECTION

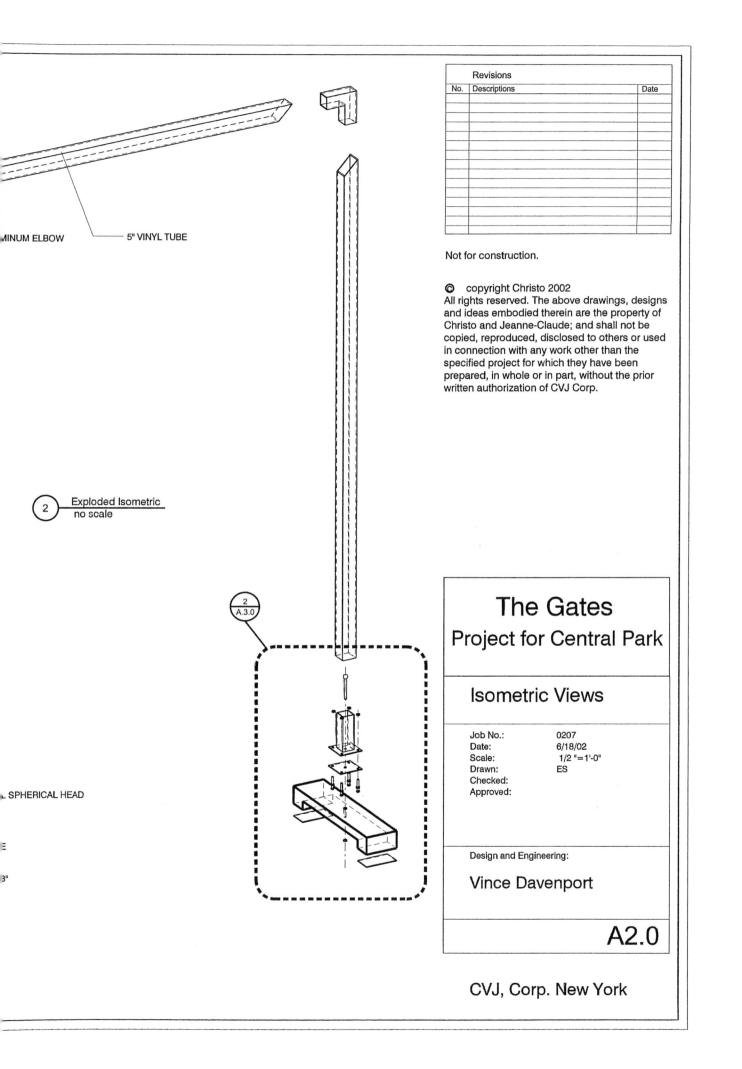

MINUM ELBOW 5" VINYL TUBE

2 Exploded Isometric
 no scale

2
A.3.0

SPHERICAL HEAD

Revisions		
No.	Descriptions	Date

The Gates
Project for Central Park

Isometric Views

Job No.:	0207
Date:	6/18/02
Scale:	1/2 "=1'-0"
Drawn:	ES
Checked:	
Approved:	

Design and Engineering:

Vince Davenport

A2.0

CVJ, Corp. New York

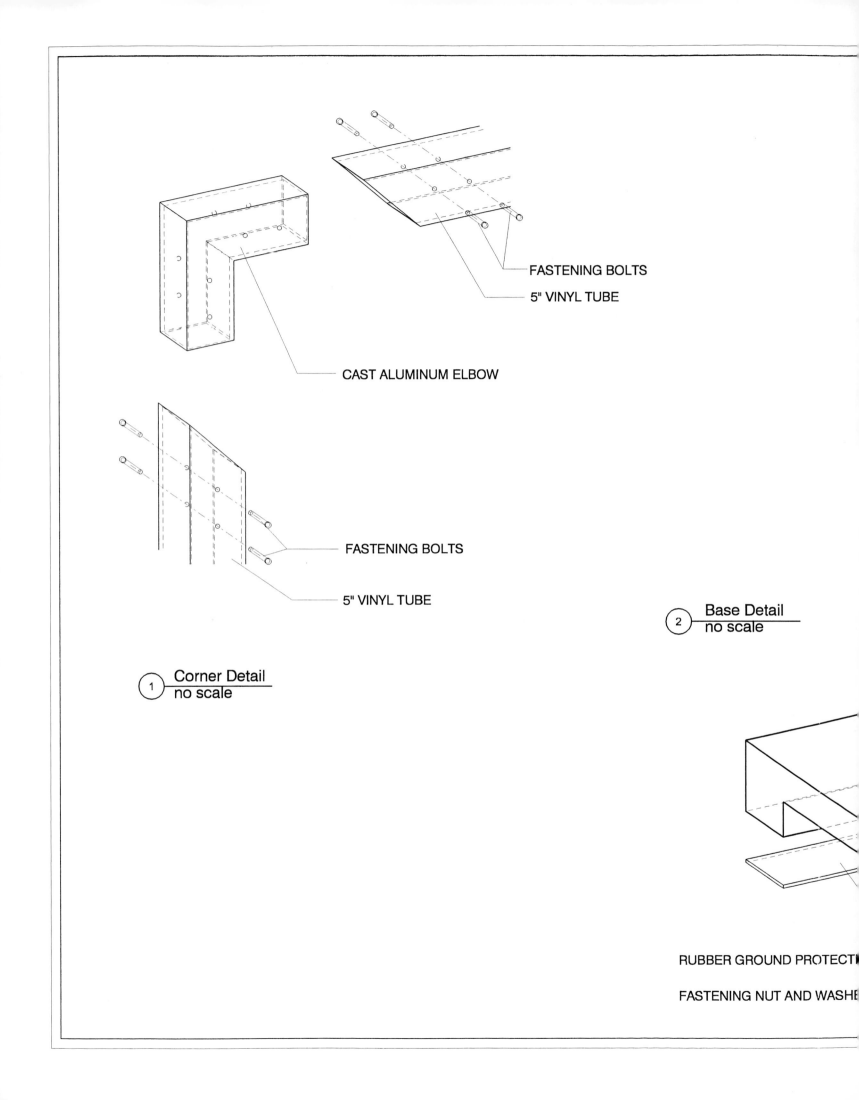

FASTENING BOLTS

5" VINYL TUBE

CAST ALUMINUM ELBOW

FASTENING BOLTS

5" VINYL TUBE

(2) Base Detail
 no scale

(1) Corner Detail
 no scale

RUBBER GROUND PROTECT

FASTENING NUT AND WASHE

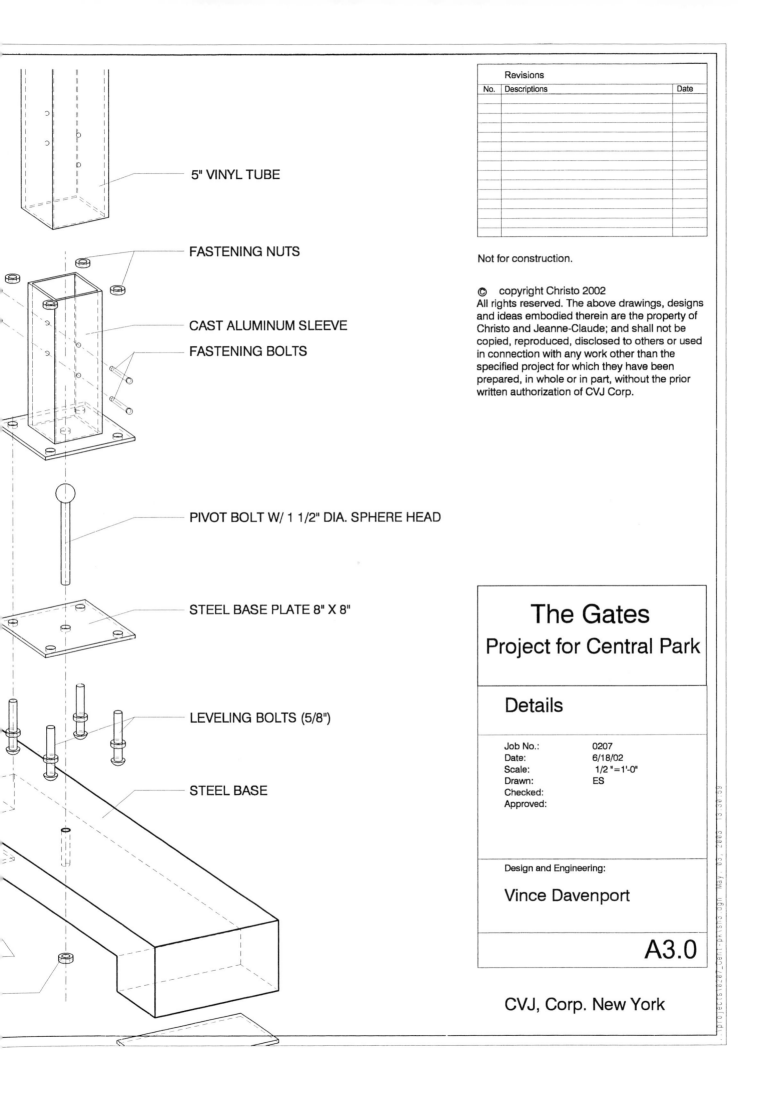

5" VINYL TUBE

FASTENING NUTS

CAST ALUMINUM SLEEVE

FASTENING BOLTS

PIVOT BOLT W/ 1 1/2" DIA. SPHERE HEAD

STEEL BASE PLATE 8" X 8"

LEVELING BOLTS (5/8")

STEEL BASE

The Gates
Project for Central Park

Details

Job No.:	0207
Date:	6/18/02
Scale:	1/2 "=1'-0"
Drawn:	ES
Checked:	
Approved:	

Design and Engineering:

Vince Davenport

A3.0

CVJ, Corp. New York

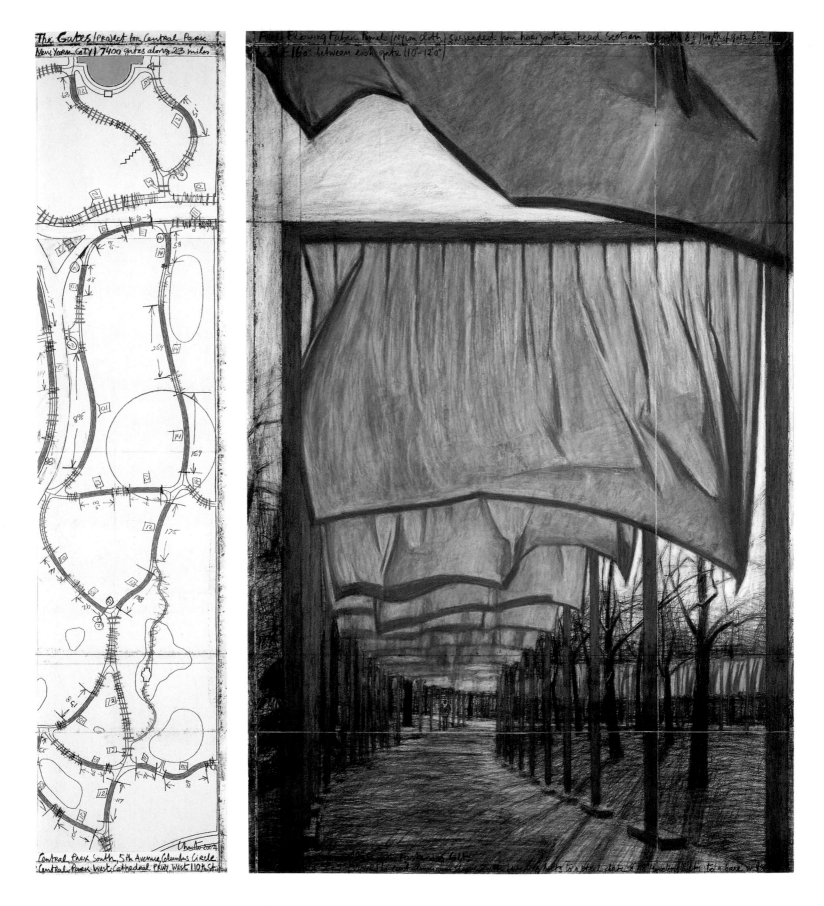

The Gates, Project for Central Park, New York City
Drawing, 2002
Pencil, charcoal, pastel, wax crayon, enamel paint and map
In two parts: 165 x 38 cm and 165 x 106.6 cm

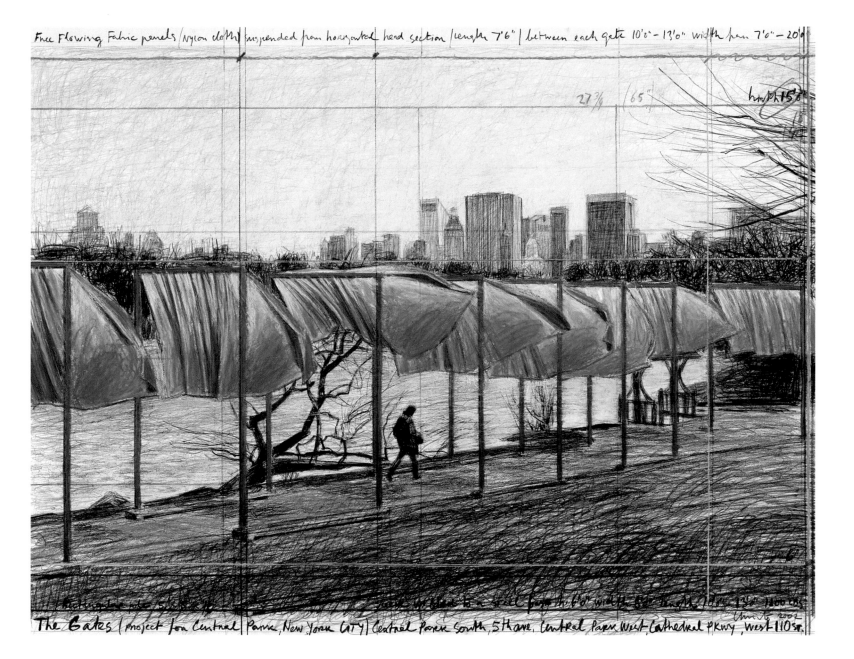

The Gates, Project for Central Park, New York City

Drawing, 2002

Pencil, charcoal, pastel and wax crayon

55.9 x 71.1 cm

Private collection, Rome, Italy

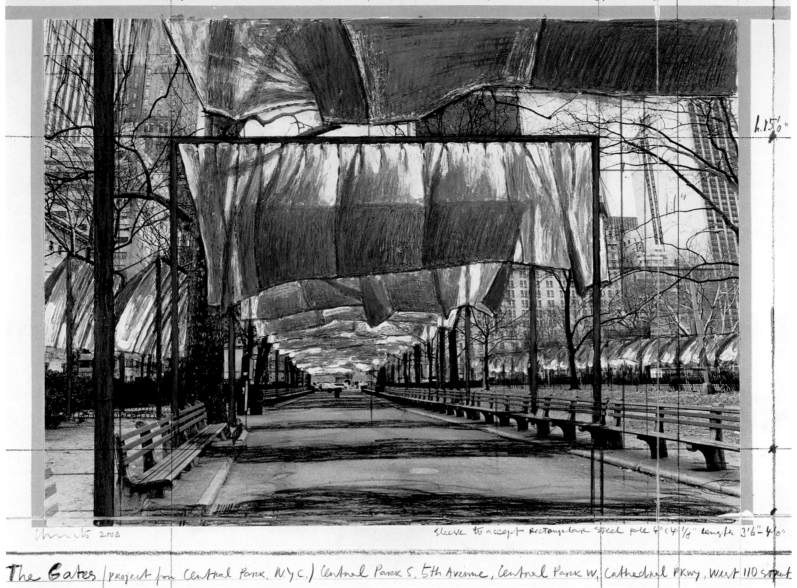

Free Flowing Fabric panels (Nylon cloth) suspended from horizontal head section (length 9'6") width of gate 7-21'0" 10'0" between each gate.

h.15'0"

Christo 2002 sleeve to accept Rectangular steel pole 4"×4 1/8" length 3'6"-4'0"

The Gates (project for Central Park, N.Y.C.) Central Park S. 5th Avenue, Central Park W, Cathedral Pkwy, West 110 street

The Gates, Project for Central Park, New York City

Collage, 2002

Pencil, enamel paint, photograph by Wolfgang Volz, wax crayon and tape

43.2 x 55.9 cm

Private collection, New York

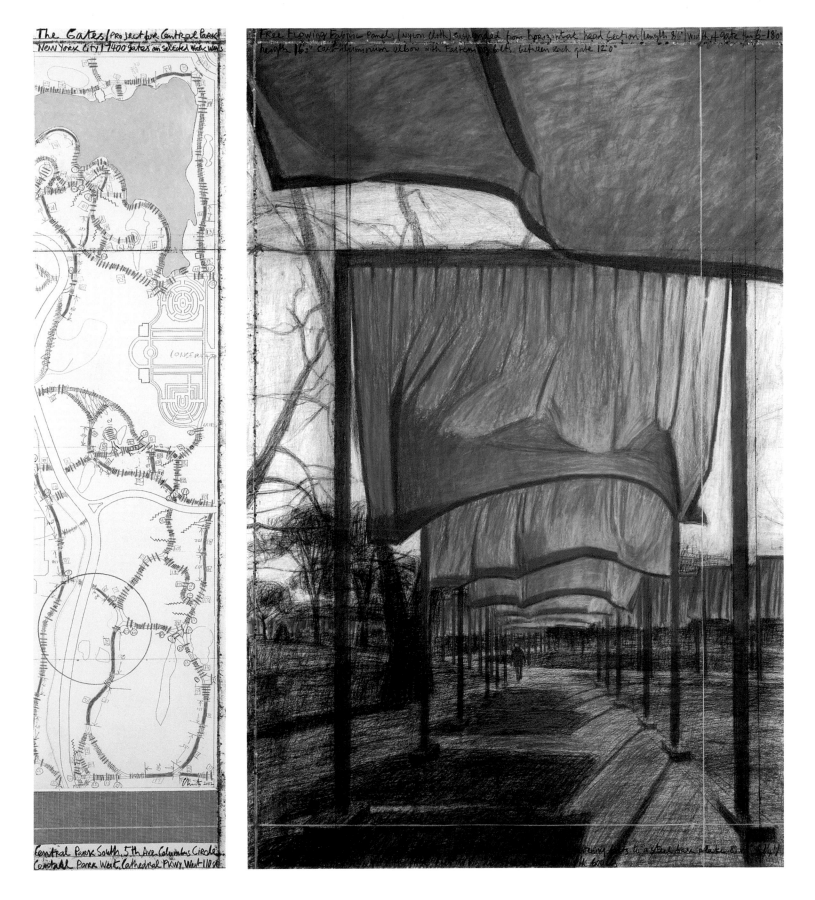

The Gates, Project for Central Park, New York City

Drawing, 2002

Pencil, charcoal, pastel, wax crayon, enamel paint, fabric sample and map

In two parts: 165 x 38 cm and 165 x 106.6 cm

Collection Museum Würth, Künzelsau, Germany

The Gates, Project for Central Park, New York, 1979–2005
Press Release

On January 22, 2003 Michael R. Bloomberg, Mayor of New York City, announced that the city has given permission to New York artists Christo and Jeanne-Claude to realize their temporary work of art: *The Gates, Central Park, New York, 1979–2005.*

The 7,500 Gates, 16 feet (4.87 meters) high with a width varying from 6 to 18 feet (1.82 to 5.48 meters) will follow the edges of the walkways and are perpendicular to the selected 23 miles of footpaths in Central Park. Free-hanging saffron-colored fabric panels suspended from the horizontal top part of the gates will come down to approximately 7 feet (2.13 meters) above the ground. The gates are spaced at 10 to 15 foot (3 to 4.5 meter) intervals allowing the synthetic woven panels to wave horizontally towards the next gate and be seen from far away through the leafless branches of the trees. The temporary work of art *The Gates* is scheduled for February 2005, to remain for 16 days, then the 7,500 Gates will be removed and the materials will be recycled.

As Christo and Jeanne-Claude have always done for their previous projects, *The Gates* will be entirely financed by the artists through C.V.J. Corporation, (Jeanne-Claude Javacheff, President) with the sale of studies, preparatory drawings and collages, scale models, earlier works of the fifties and sixties, and original lithographs on other subjects.

The artists do not accept sponsorship of any kind. Neither New York City nor the Park Administration shall bear any of the expenses for *The Gates.*

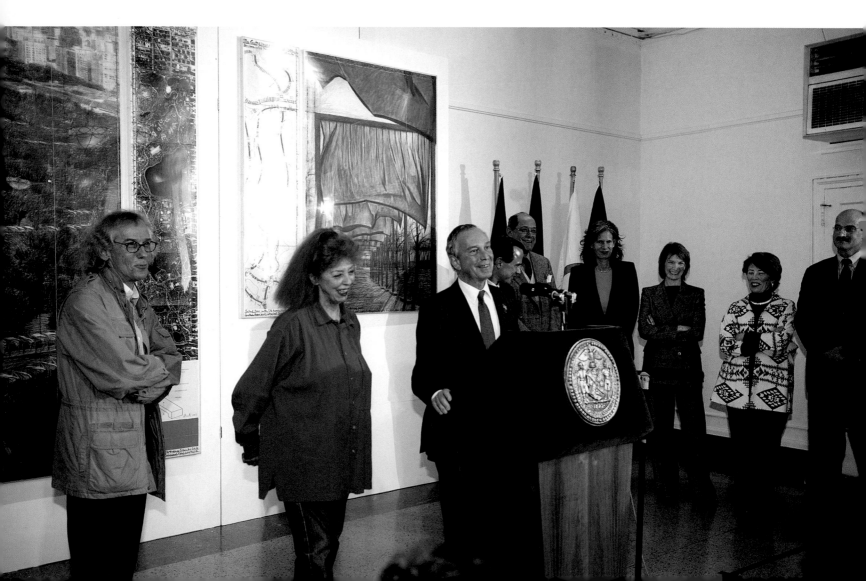

The Gates will provide employment for thousands of New York City residents:

- ▸ Manufacturing and assembling of the gates structures
- ▸ Installation workers
- ▸ Maintenance teams around the clock, in uniform and with radios
- ▸ Removal workers.

The 5-inch (12.7 cm) square vertical and horizontal poles will be extruded in 65 miles (104.6 km) of recyclable saffron colored vinyl. The vertical poles will be secured by 15,000 narrow steel base footings, 600 pounds (275 kilograms) each, positioned on the paved surfaces. There will be no holes in the ground at all.

The off-site fabrication of the gates structures and assembly of the 7,500 fabric panels made of 1,089,882 square feet (101,250 square meters) of fabric will be done in local workshops and factories.

The on-site installation of the bases, by small teams, spread about in the park, will disturb neither the maintenance and management of Central Park nor the everyday use of the park by the people of New York.

The final installation of the 7,500 gates will be done, in five days, simultaneously by hundreds of workers.

The unfurling of the fabric panels will bloom in one day. A written contract has been drafted between the City of New York and the Department of Parks and Recreation and the artists. The contract requires the artists to provide, among other terms and conditions:

- ▸ Personal and property liability insurance holding harmless the City, the Department of Parks and Recreation, and the Central Park Conservancy.
- ▸ Restoration Bond providing funds for complete removal.
- ▸ Full cooperation with the Department of Parks and Recreation, the Central Park Conservancy, the New York Police Department, the New York City Arts Commission, the Landmarks Commission and the Community Boards.
- ▸ Clearance for the usual activities in the park and access of rangers, maintenance, clean-up, police and emergency vehicles.
- ▸ The artists shall pay all costs of the park's supervision directly related to the project.
- ▸ Neither vegetation nor rock formations shall be disturbed. *The Gates* will be clear of rocks, tree roots and low branches.
- ▸ Only vehicles of small size will be used and will be confined to existing walkways during installation and removal.
- ▸ The people of New York will continue to use Central Park as usual.
- ▸ After the removal, the site will be inspected by the Department of Parks and Recreation which will be holding the bond until satisfaction.

For those who walk through *The Gates*, following the walkways and staying away from the grass, *The Gates* will be a golden ceiling creating warm shadows. When seen from the buildings surrounding Central Park, *The Gates* will seem like a golden river appearing and disappearing through the bare branches of the trees and will highlight the shape of the footpaths.

The 16-day-duration work of art, free to all, will be a long-to-be-remembered joyous experience for every New Yorker, as a democratic expression that Olmsted invoked when he conceived a "central" park. The luminous, moving fabric will underline the organic design of the park, while the rectangular poles will be a reminder of the geometric grid pattern of the city blocks around the park. *The Gates* will harmonize with the beauty of Central Park.

On January 22, 2003 during his press conference at the Arsenal in Central Park, New York City Mayor Michael Bloomberg announced that a 43 page contract has been signed between the City and the artists, giving Christo and Jeanne-Claude permission to create *The Gates, Central Park, 1979–2005*. From left to right: Christo, Jeanne-Claude, Michael Bloomberg, Adrian Benepe, Commissioner of Parks and Recreation, Gordon Davis, former Commissioner of Parks and Recreation, Kate Levin, Commissioner of Cultural Affairs, Patricia Harris, Deputy Mayor, Regina Peruggi, President of the Central Park Conservancy, and Douglas Blonsky, Central Park Administrator.

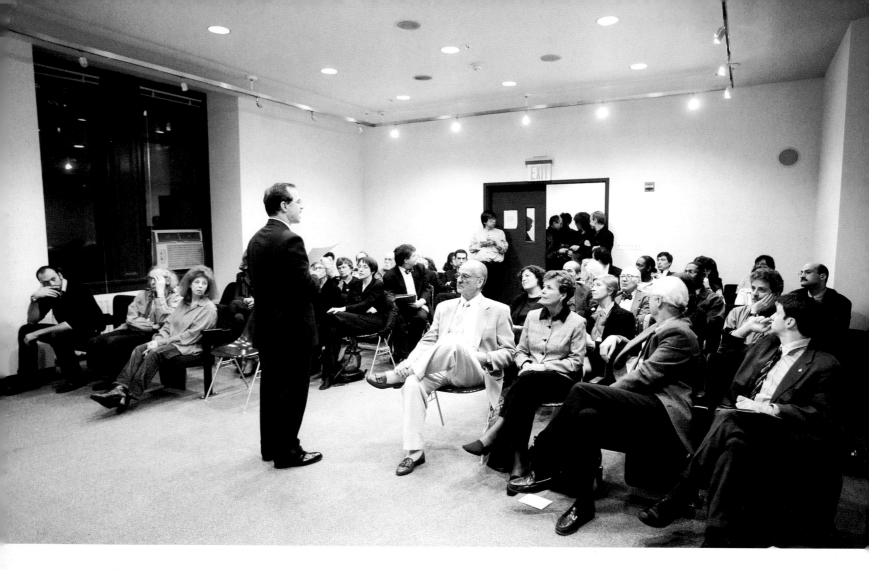

Adrian Benepe, Commissioner of Parks and Recreation, answers questions to the Landmarks Preservation Commission, on March 19, 2003, in the Municipal Building at number 1 Centre Street.

Opposite, top:
On Wednesday March 19, 2003, at 6.30 p.m., the Gates team presented the project to the Executive Board of Community Board number 10 at West 125 Street, and then rushed to the next meeting. At 7 p.m. the Community Board number 8 started its meeting at East 67 Street, and was kind enough to schedule *The Gates* last on its agenda, giving the team enough time to arrive from their CB 10 presentation.

Opposite:
Jack Linn, Deputy Parks Commissioner, on the right, explains the details of the 44 page contract between the City and the artists. Documentary filmmaker Albert Maysles, who started his film *The Gates* in 1980, is filming the meeting.

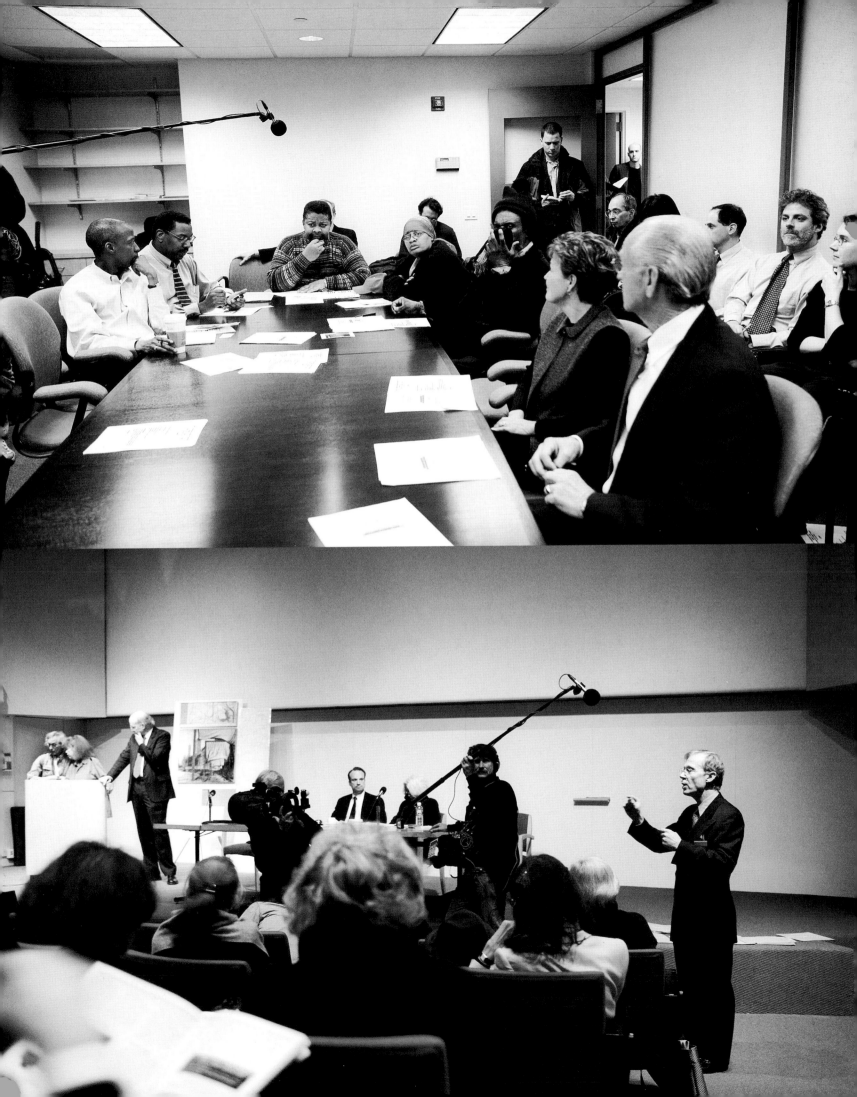

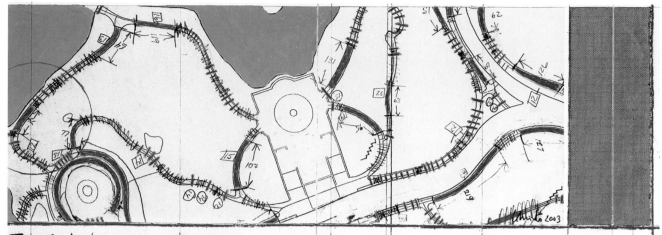

The Gates (Project for Central Park New York City) Central Park South, 5th. Avenue, Central Park West West 110 th. St.

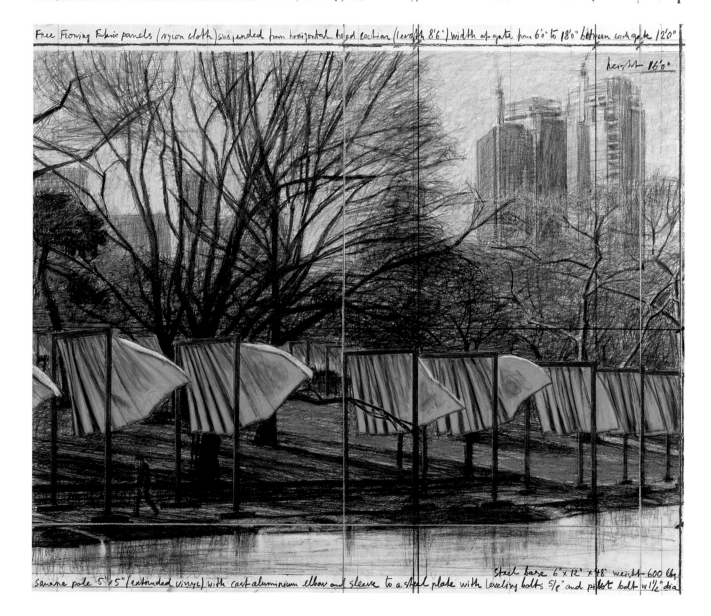

Free Flowing Fabric panels (nylon cloth) suspended from horizontal head section (length 8'6") width of gate from 6'0" to 18'0" between each gate 12'0"

height 16'0"

Steel base 6" x 12" x 48" weight 600 lbs.

square pole 5" x 5" (extruded vinyl) with cast aluminium elbow and sleeve to a steel plate with leveling bolts 5/8" and pilot bolt w 1 1/2" dia

The Gates, Project for Central Park, New York City
Collage, 2003
Pencil, fabric, charcoal, wax crayon, pastel, enamel paint, map and fabric sample
In two parts: 30.5 x 77.5 cm and 66.7 x 77.5 cm
Private collection, New York State

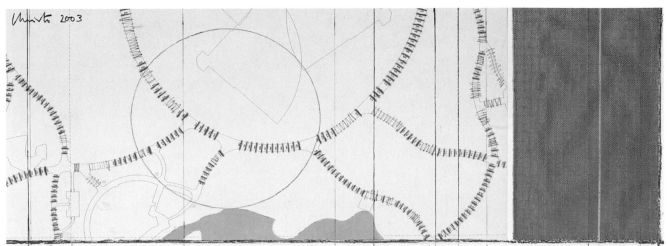

The Gates (Project for Central Park, New York City) Central Park South, 5th. Avenue, Central Park West, West 110 H. St.

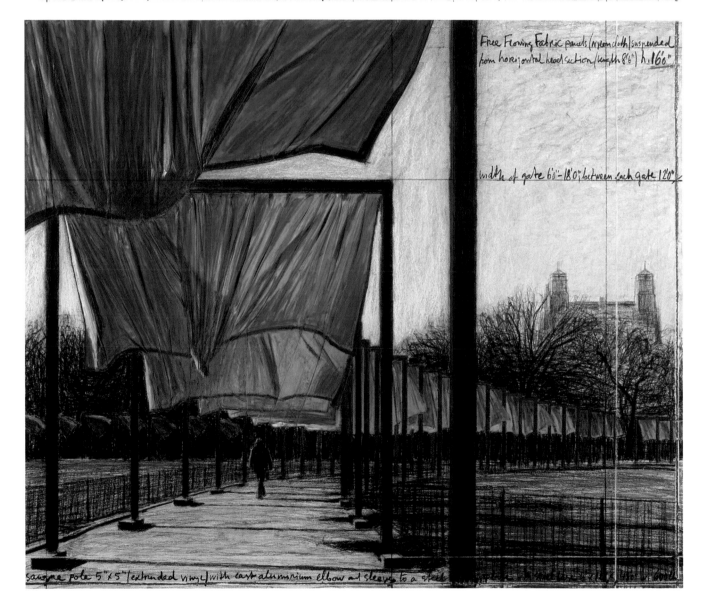

The Gates, Project for Central Park, New York City
Collage, 2003
Pencil, fabric, charcoal, wax crayon, pastel, enamel paint, map and fabric sample
In two parts: 30.5 x 77.5 cm and 66.7 x 77.5 cm
Private collection, New York

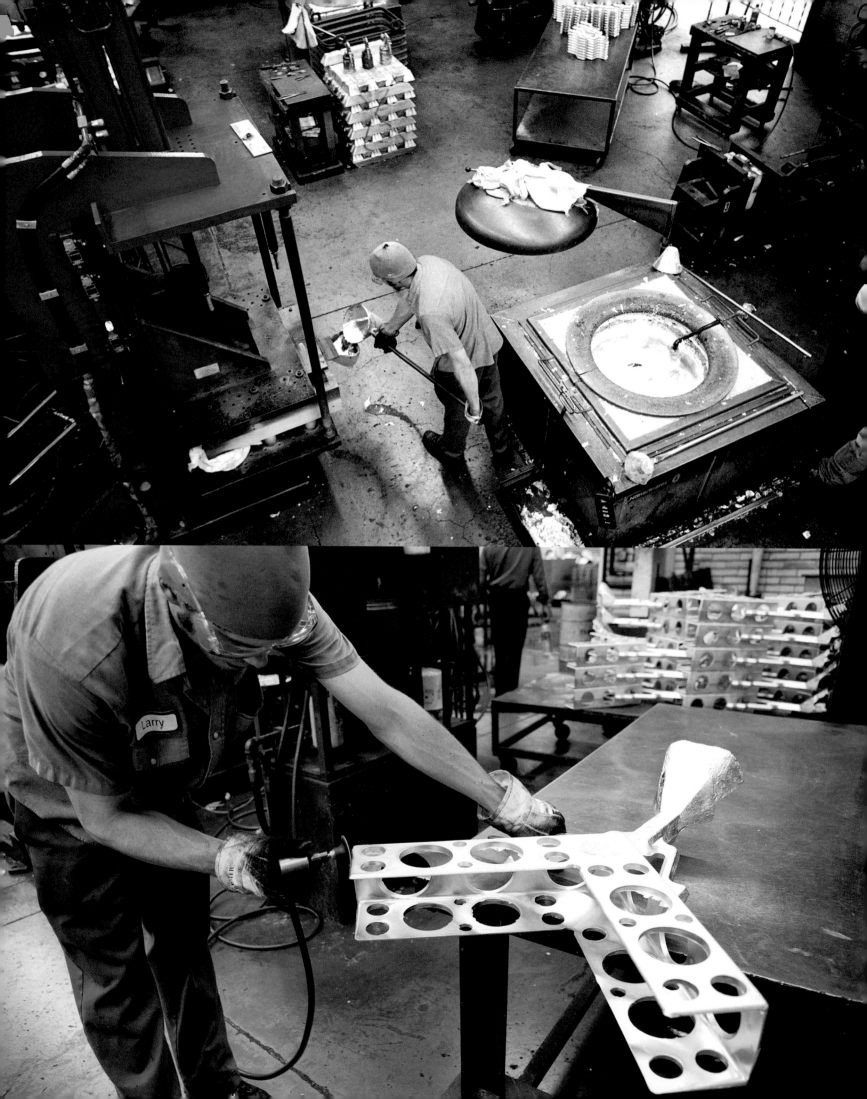

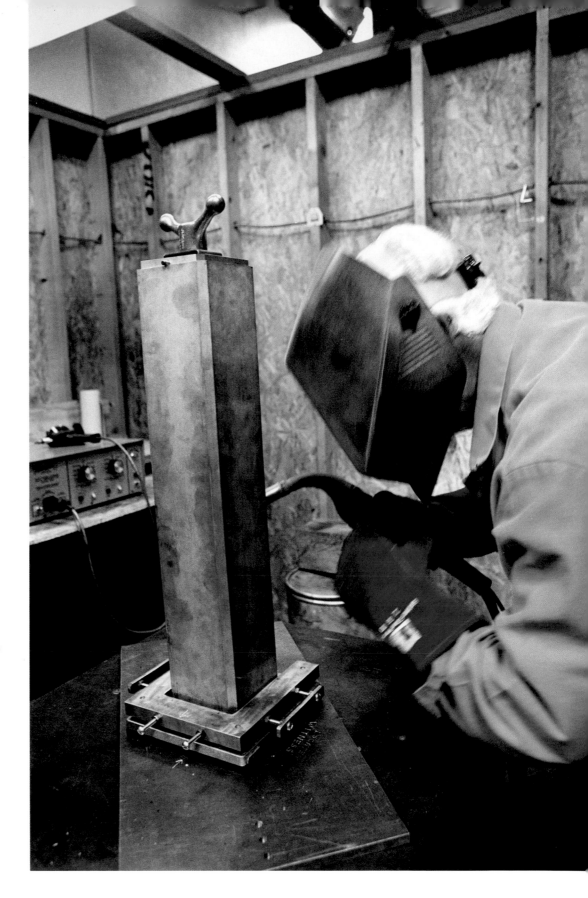

Dan Falco is ready to weld the two aluminum parts forming the lower base anchor sleeve. At the Queens, NY, assembly plant, the 15,000 sleeves are inserted into the lower part of the two vertical vinyl poles, ready to be brought to Central Park. A total of 165,704 bolts and self-locking nuts will secure the poles to the steel footing weights.

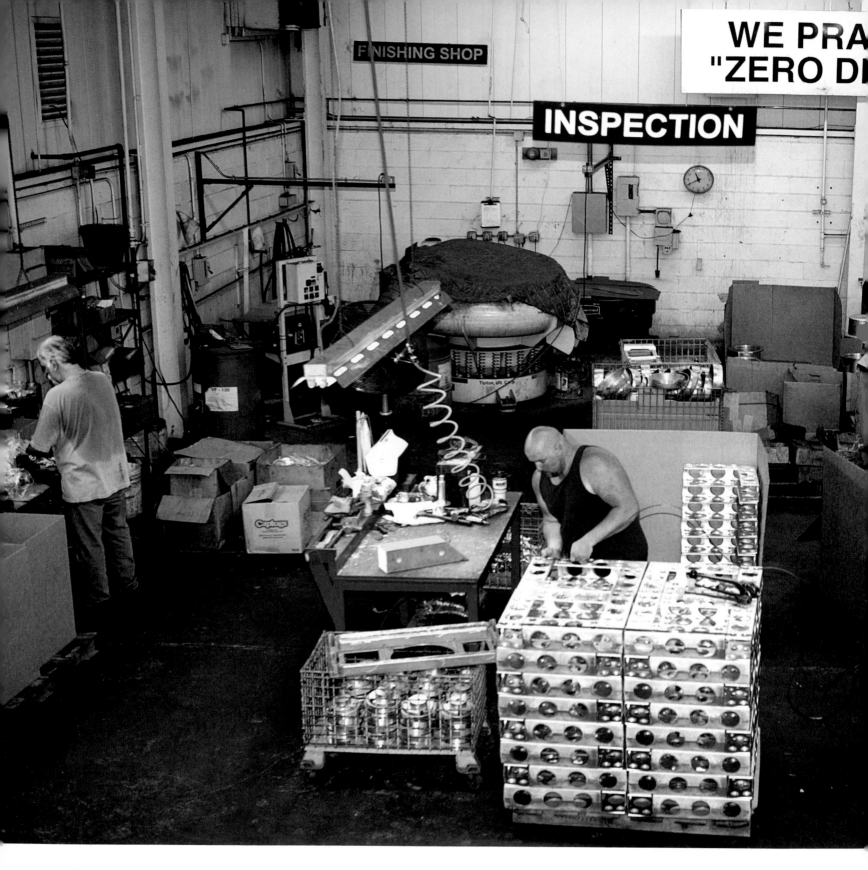

Russel Bowen's task is to inspect the 15,000 specially designed, recyclable, cast aluminum upper corner shoulder sleeve reinforcements. After finishing grinding the rough edges, he makes sure that they fit into the short test sample of vinyl pole on the table. A total of 60 miles (96.5 kilometers) of vinyl pole will be used for the vertical and horizontal poles. He then prepares a stack of 64 corner sleeves on a pallet, ready for shipping to the assembly plant in Queens, NY.

46

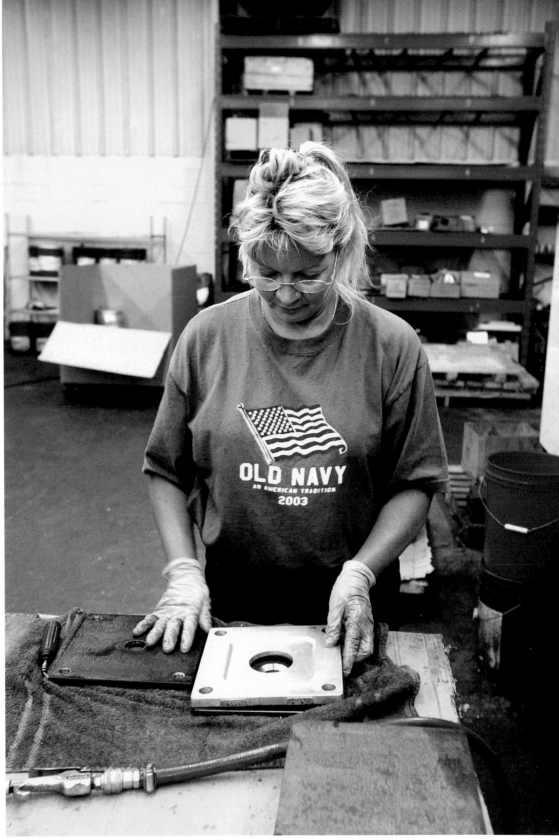

Diane Aschenbrenner is in charge of quality control for the 15,064 steel leveling plates. The half inch thick, 8 x 8 inch (20.3 x 20.3 cm) steel leveling plate will be secured between the base anchor sleeve and the steel base. It has a central pivoting bolt, which will ensure the perfect verticality of the poles, even when the walkways are inclined.

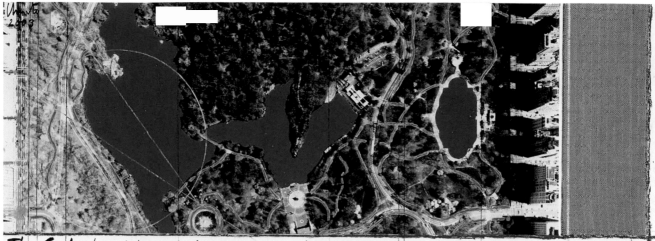

The Gates (project for Central Park, New York City) Central Park South, 5th Avenue, Central Park West, West 110th St.

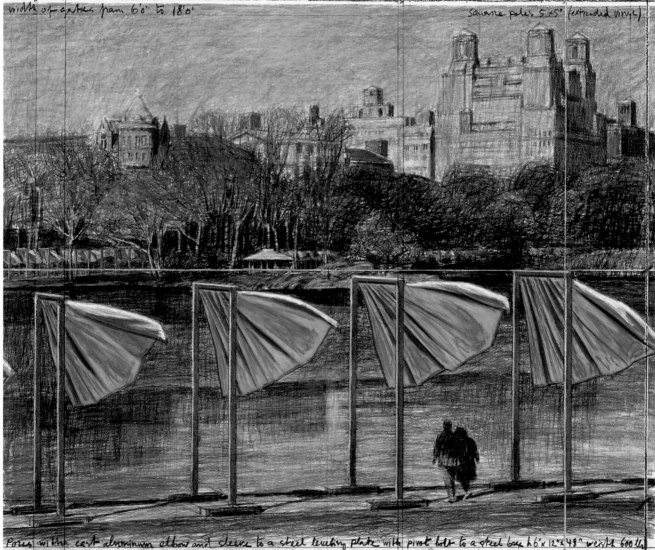

Free Flowing Fabric Panels (nylon cloth) suspended from horizontal head section (Length 8'6") between each gate 12'0" height 16'0" width of gates from 6'0" to 18'0" square poles 5×5" (extruded vinyl)

Poles with cast aluminum elbow and sleeve to a steel leveling plate with pivot bolt to a steel base h6"× 12"×48" weight 600 lbs

The Gates, Project for Central Park, New York City
Collage, 2003
Pencil, fabric, charcoal, wax crayon, pastel, enamel paint, aerial photograph and fabric sample
In two parts: 30.5 x 77.5 cm and 66.7 x 77.5 cm
Private collection, Sweden

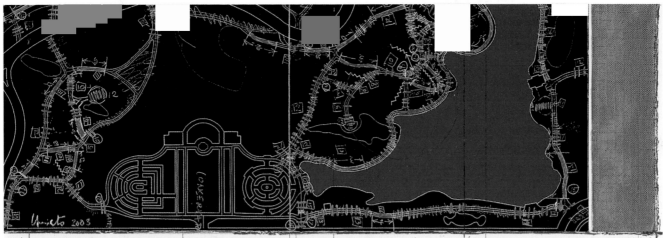

The Gates (Project for Central Park, New York City) Central Park South, 5th. Avenue Central Park West, West 110th Street

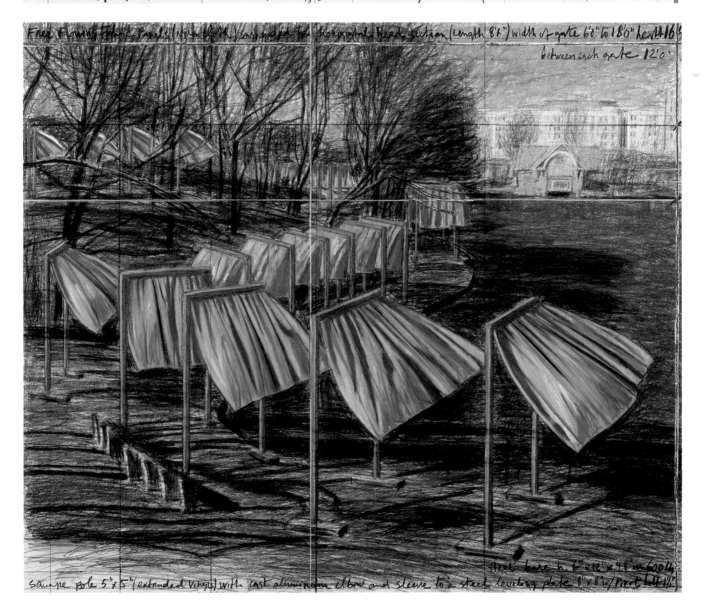

Free Flowing Fabric Panels (Nylon cloth) suspended for horizontal Upper section (Length 86") width of gate 6'0" to 18'0" height 16'

between each gate 12'0"

square pole 5"x 5" (extruded vinyl) with cast aluminium elbow and sleeve to a steel leveling plate 8"x 8" Pivot bolt 1½"

steel base h. 6"x18"x 48" in. 6004

The Gates, Project for Central Park, New York City
Collage, 2003
Pencil, fabric, charcoal, wax crayon, pastel, enamel paint, map and fabric sample
In two parts: 30.5 x 77.5 cm and 66.7 x 77.5 cm
Private collection, New York

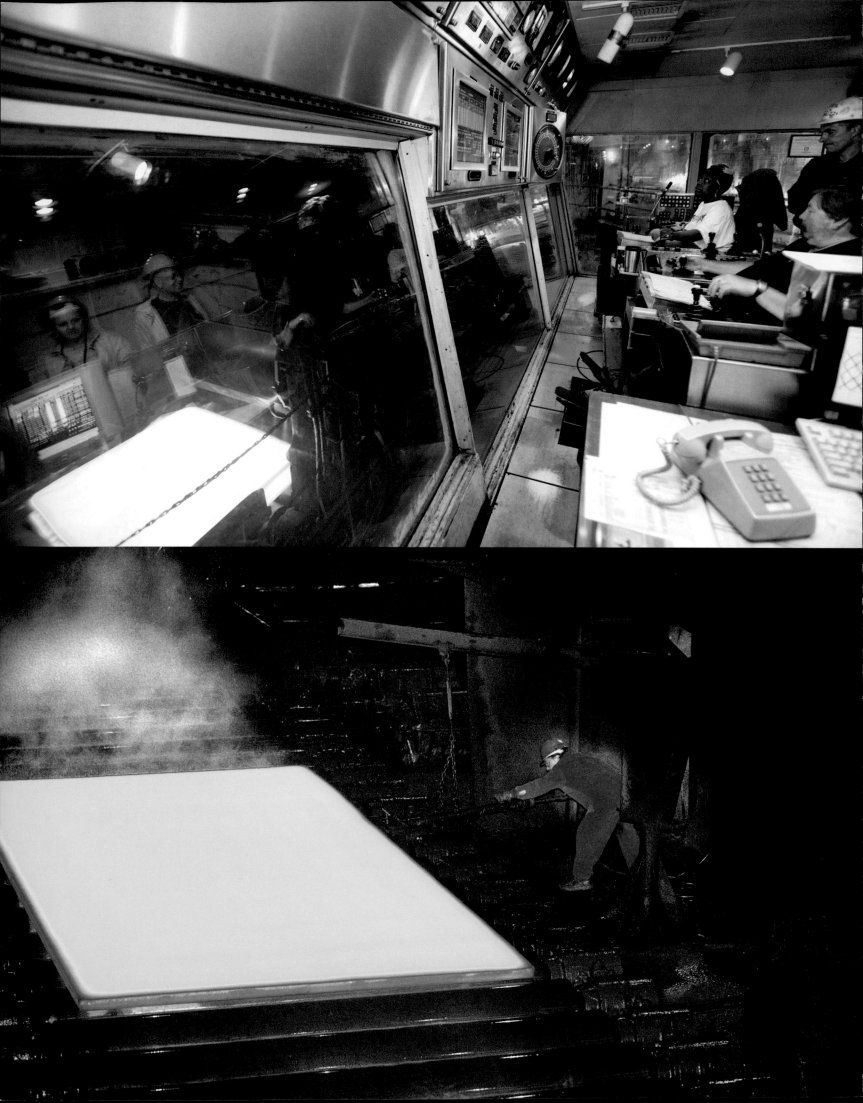

Opposite, top:
From the air conditioned automation control room, Gary Layton and Stacy Jones operate the mill to hot roll the steel slabs and ingots into plates, using horizontal and vertical rolls to meet the desired dimension.

Opposite:
The thick red-hot steel plate is rolled many times, thinning and elongating it until the 3″ thickness is obtained. A mill technician is checking it.

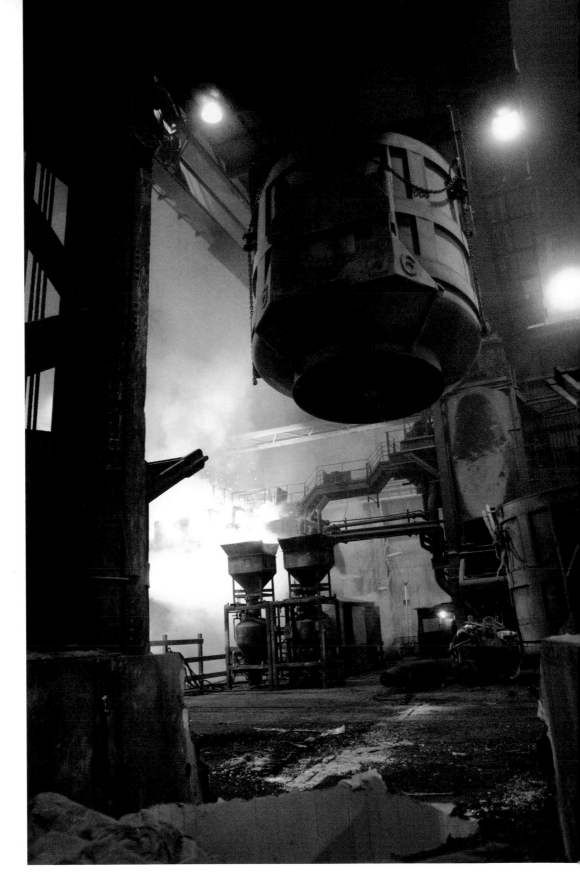

When visiting the ISG steel mill in Coatesville, PA, visitors are kindly issued with hard hats, goggles, earplugs and workers' smocks. The volcano-like furnace spits tons of red-hot liquid steel in a cloud of steam and dust, producing deafening roars. 5,290 tons are necessary for *The Gates* base weights.

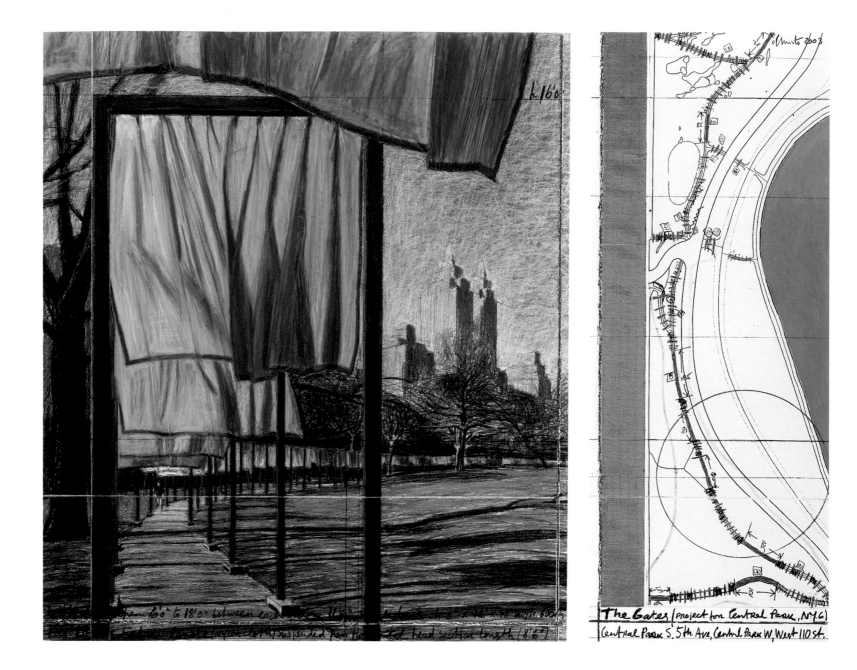

The Gates, Project for Central Park, New York City
Collage, 2003
Pencil, fabric, charcoal, wax crayon, pastel, enamel paint, map and fabric
sample
In two parts: 77.5 x 66.7 cm and 77.5 x 30.5 cm
Private collection, New York

The Gates, Project for Central Park, New York City
Collage, 2003
Pencil, fabric, charcoal, wax crayon, pastel, enamel paint, map and fabric
sample
In two parts: 30.5 x 77.5 cm and 66.7 x 77.5 cm
Private collection, New York

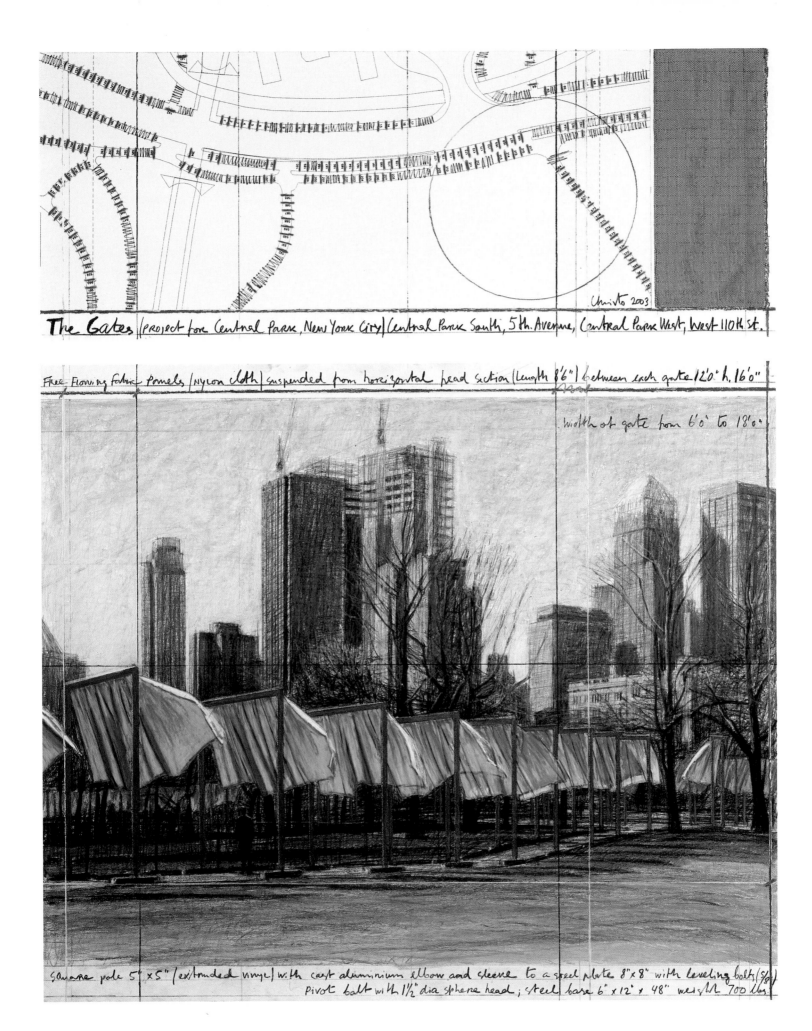

Christo 2003

The Gates (Project for Central Park, New York City) Central Park South, 5th. Avenue, Central Park West, West 110th St.

Free-Flowing Fabric Panels (nylon cloth) suspended from horizontal head section (Length 8'6") between each gate 12'0" h. 16'0"

width of gate from 6'0" to 18'0"

Square pole 5" x 5" (extruded vinyl) with cast aluminium elbow and sleeve to a steel plate 8"x 8" with leveling bolts (5/8") Pivot bolt with 1½" dia sphere head; steel base 6" x 12" x 48" weight 700 lbs.

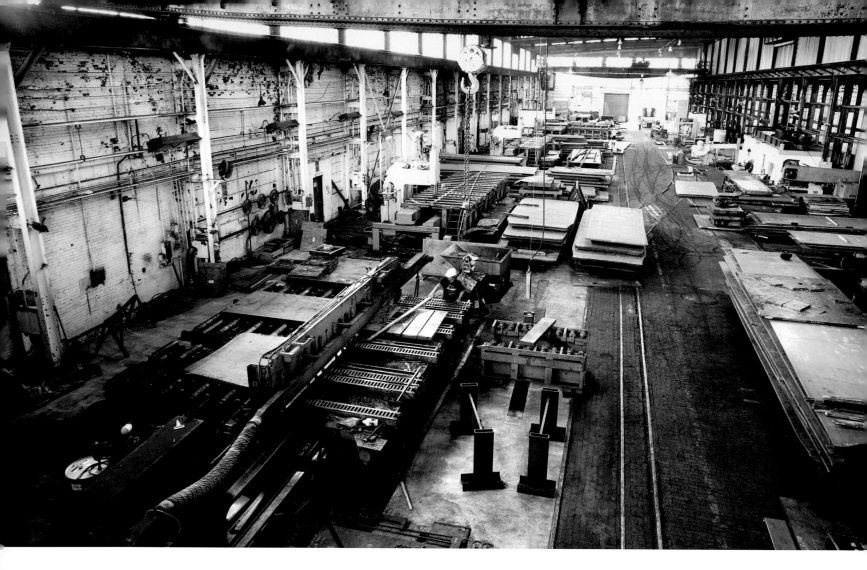

At the C.C.Lewis steel plant in Conshohocken, PA, some of the steel plates have been received from the ISG plant in Coatesville, PA.

Opposite, top:
Under the supervision of Jeff Jarosz, a 12,252 pound (5,557 kg), 3″ (7.62 cm) thick, 60″ x 240″ (1.52 x 6.09 m) steel plate is being sliced lengthwise to prepare the steel base weights. A 29″ (73.6 cm) diameter circular saw with carbide tipped teeth takes twelve minutes to make one cut. Steel "feet" are welded to the base weights.

Opposite:
A total of 809 steel plates were manufactured at the ISG mill in Coatesville, PA. From there they were shipped to the two C. C. Lewis plants, one in Springfield, MA and one in Conshohocken, PA. Here, a 12,252 pound (5,557 kg) steel plate, 3″ (7.62 cm) thick, 60″ x 240″(1.52 x 6.09 m), is delivered to the C. C. Lewis plant in Springfield, MA. There it will be cut by a band saw into 12″ (30.5 cm) wide sections for the base weights.

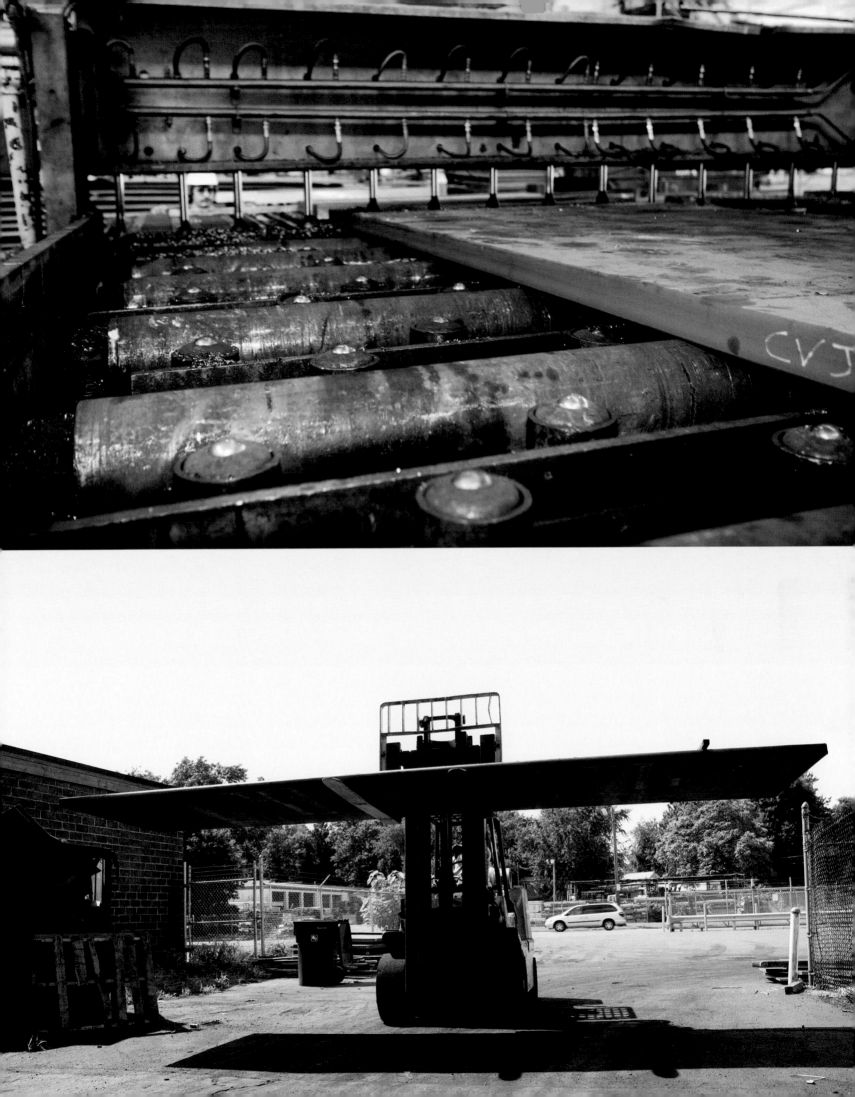

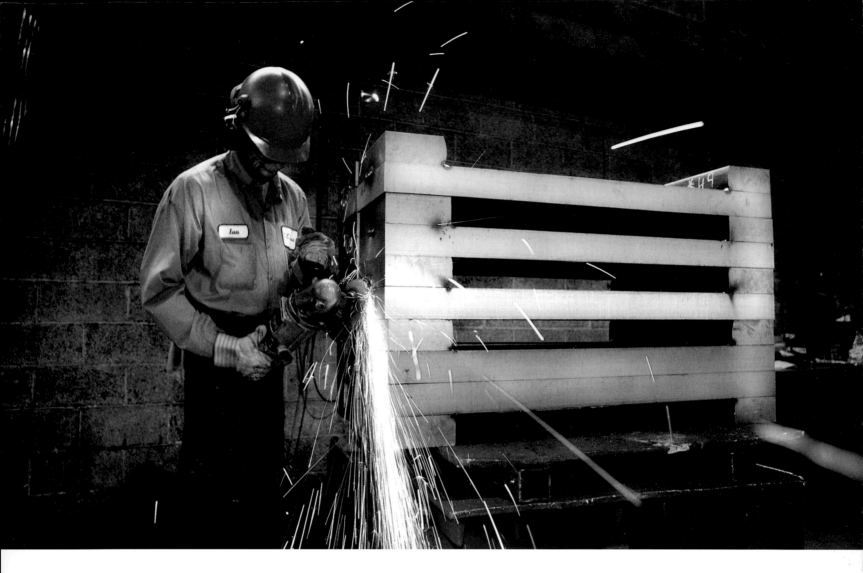

At the C.C. Lewis steel plant in Springfield, MA, Ian Smith is removing snag from the weld points where the bases and the "feet" have been welded together. The length, thickness, width and weight of the base weights, including the "feet" vary with the width of the walkways. There are 23 different widths in the 23 miles (37 kilometers) of the walkways used for *The Gates* in Central Park. The average dimensions of the bases are: 48″ x 6″ x 12″, 750 pounds (122 x 15.2 x 30.4 cm, 340 kg). For the 18-foot-wide walkways, the base weights have to be heavier: 60″ x 6.5″ x 12″, 835 pounds (152.4 x 16.5 x 30.5 cm, 378 kg). Only the 12″ x 12″ (30.5 x 30.5 cm) area of the "feet" will rest on the hard surface of the walkways in Central Park.

Opposite, top:
After the paint has dried, Greg and Sean Hall, the sons of welder Michael Hall, apply a piece of thick rubber to the undersides of the "feet" of the base weights to further protect the surface of the walkways in the Park. The weights are then protected with thick cardboard, ready to be shipped to the 25,000 square foot (2,250 m²) assembly plant and the 8,000 square foot (720 m²) storage in Queens, NY.

Opposite:
Dave Cahoon is operating a Kasto K3 cut-off saw which simultaneously drills a hole into the base weight and cuts off one of the base "feet".

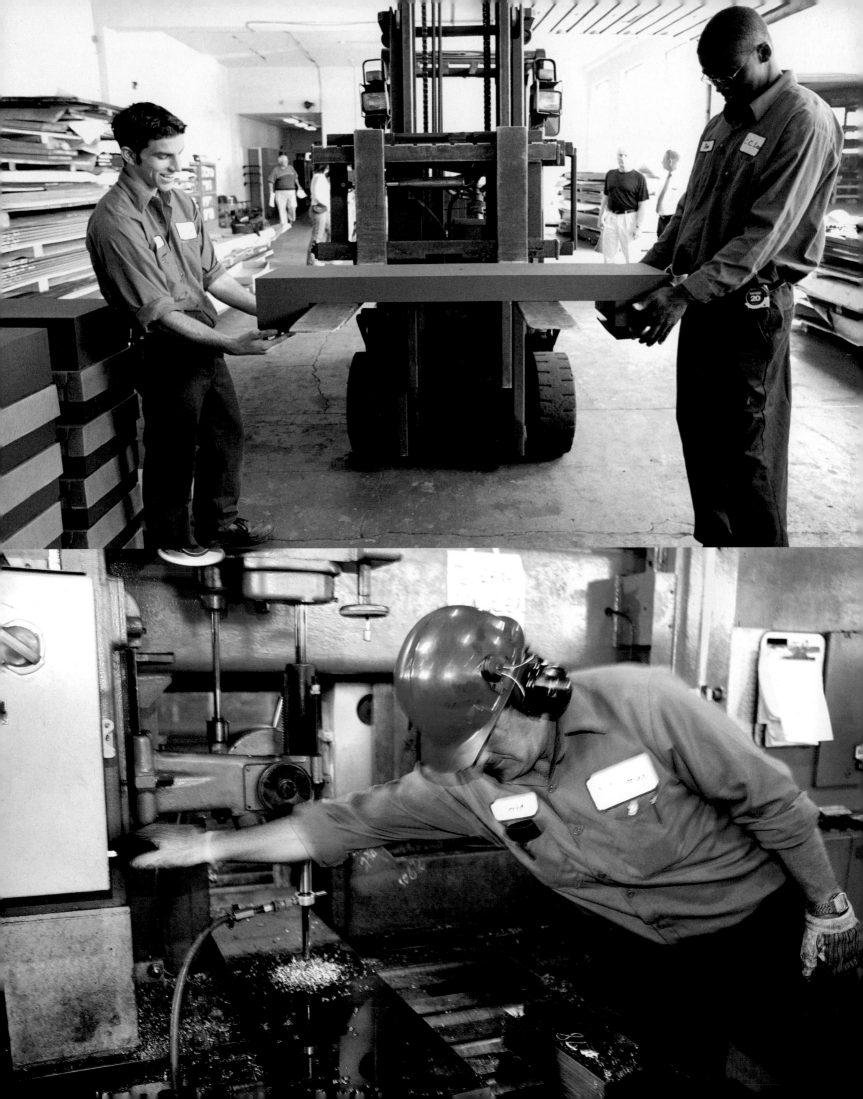

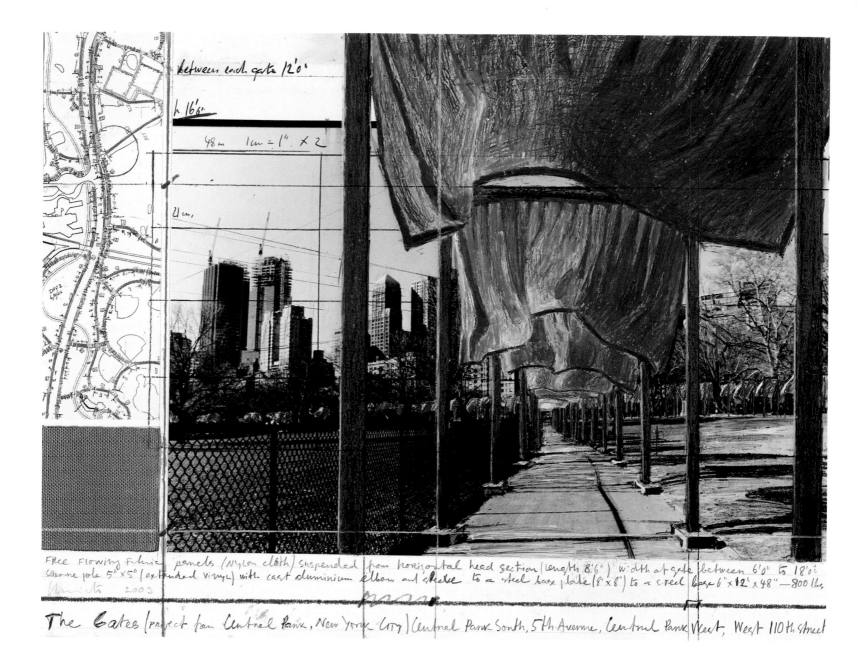

The Gates, Project for Central Park, New York City
Collage, 2003
Pencil, enamel paint, photograph by Wolfgang Volz, wax crayon, map and
fabric sample
43.2 x 55.9 cm
Private collection, USA

The Gates, Project for Central Park, New York City
Collage, 2003
Pencil, enamel paint, photograph by Wolfgang Volz, wax crayon,
map and fabric sample
28 x 21.5 cm
Private collection, USA

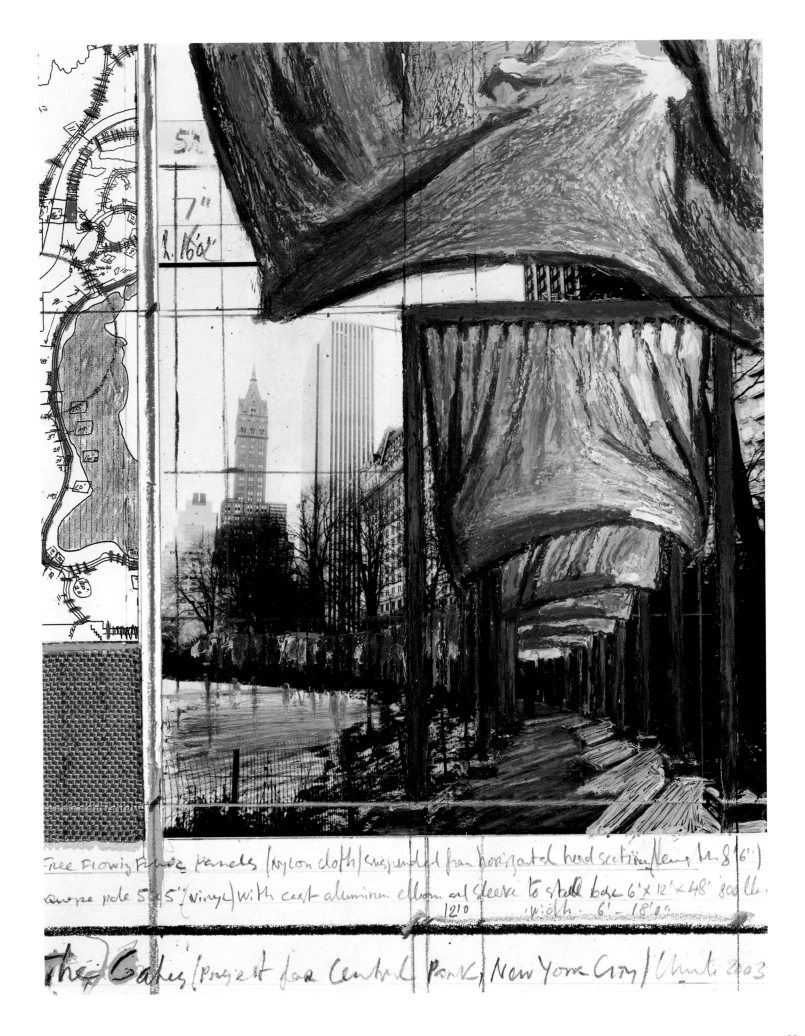

Free Flowing Fabric panels (nylon cloth) suspended from horizontal head section (length 16") — canopy pole 5"x5" (vinyl) with cast aluminum elbow and sleeve to steel base 6"x 12" x 48" 800 lbs. width 6'- 18'11"

1210

The Gates (Project for Central Park, New York City) Christo 2003

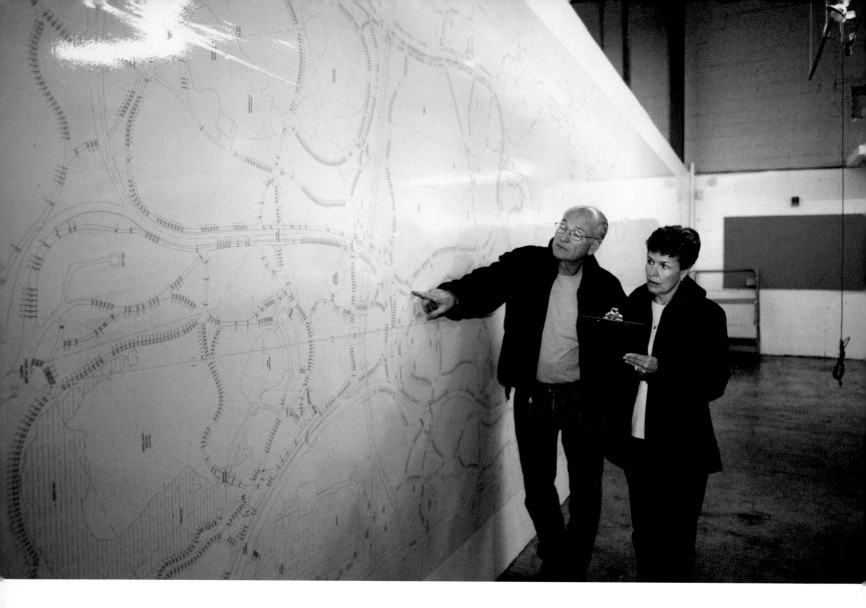

At the assembly plant in Queens, NY, Vince Davenport, chief engineer and director of construction and Jonita Davenport, project director, are standing in front of the 8 feet high, 30 feet long (2.40 x 9 m) map of Central Park. The position of the 7,500 gates is marked along the 23 miles (37 km) of walkways. The numbers next to each gate indicates the area, the width of the walkway (there are 23 different widths of walkways) and the specific number of that gate.

Opposite:

119,556 miles (192,366 km) of nylon thread, extruded in saffron color, are being woven into 1,092,200 square feet (98,298 m²)of recyclable rip-stop nylon fabric at the J.Schilgen Company in Emsdetten, Germany. The fabric will then be shipped to the sewing factory.

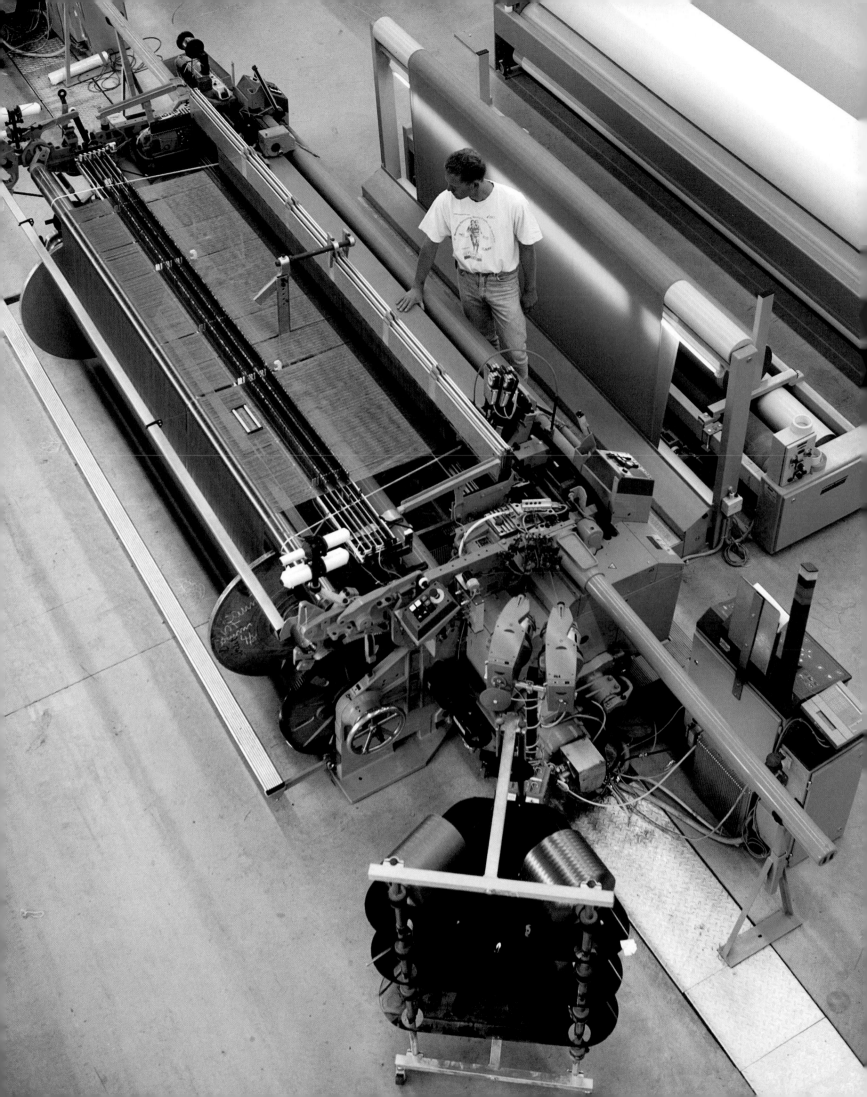

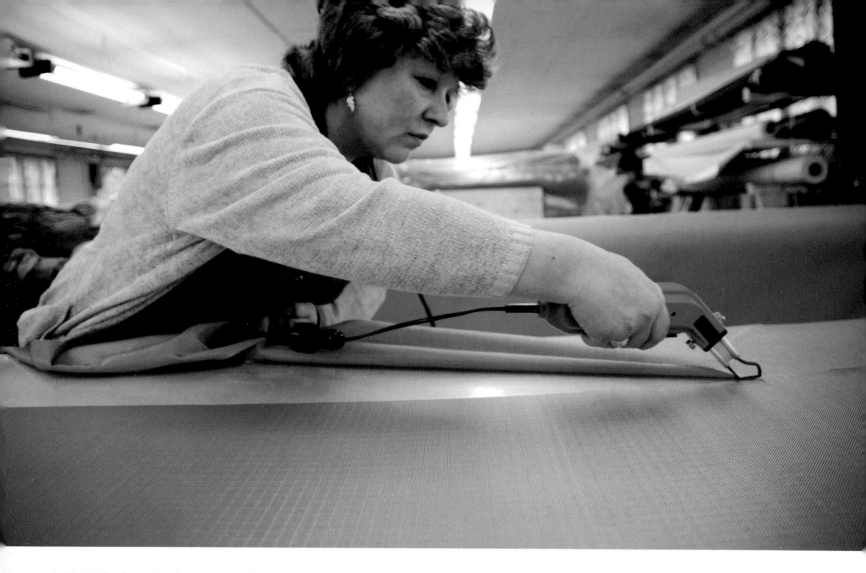

At Bieri-Zeltaplan, in Taucha, Germany, the fabric is cut and sewn into 7,500 panels of various widths, according to the 23 widths of the walkways. Sabine Spohr cuts a panel with a "hot-knife". The width of the roll of the woven fabric has been calculated so that it will become the height of the panel, allowing to make only one cut per panel.

Opposite:
The fabric panel is carefully rolled around a 4 inch (10 cm) diameter cardboard tube, holding the folds smoothly in place.

Andreas Marks and Roland Eilenberger prepare a sewn panel, forming the fabric folds by hand, before rolling it around a cardboard tube.

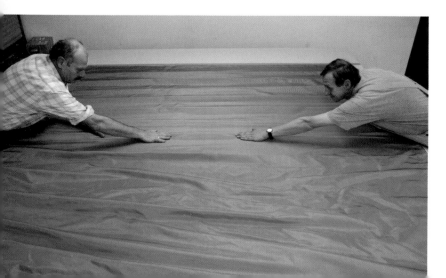

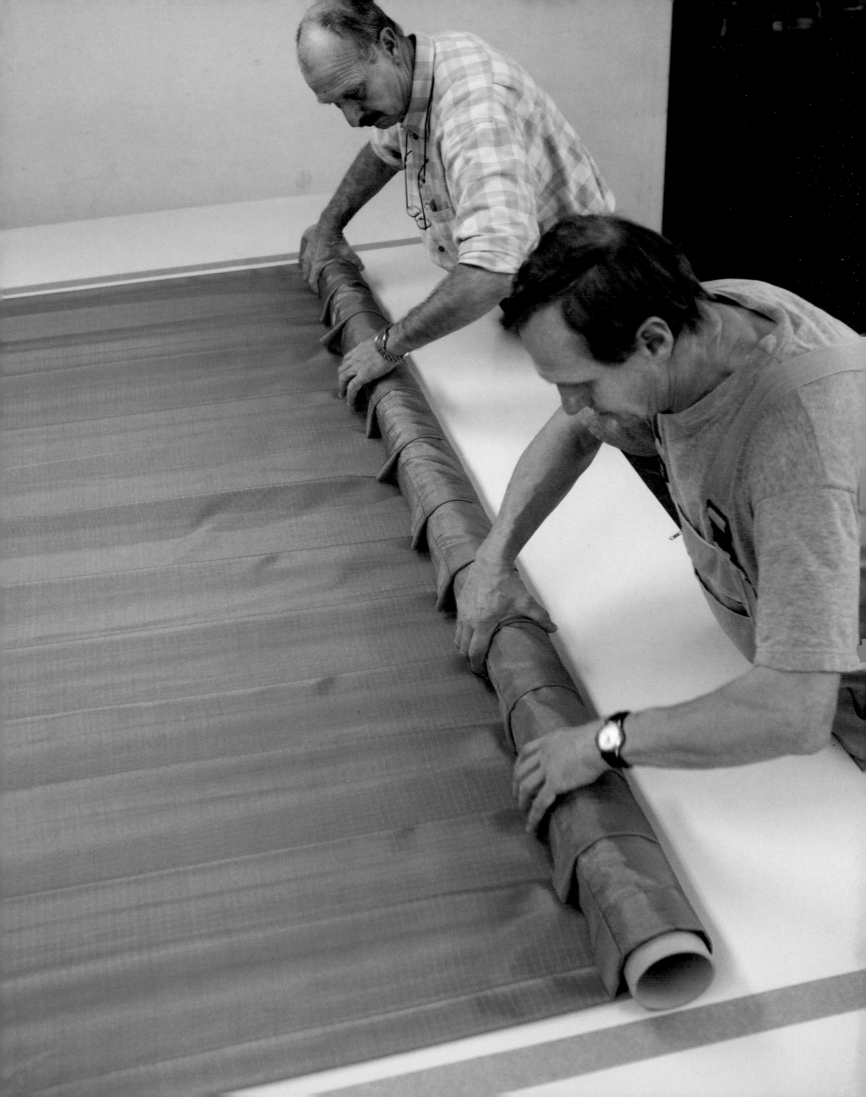

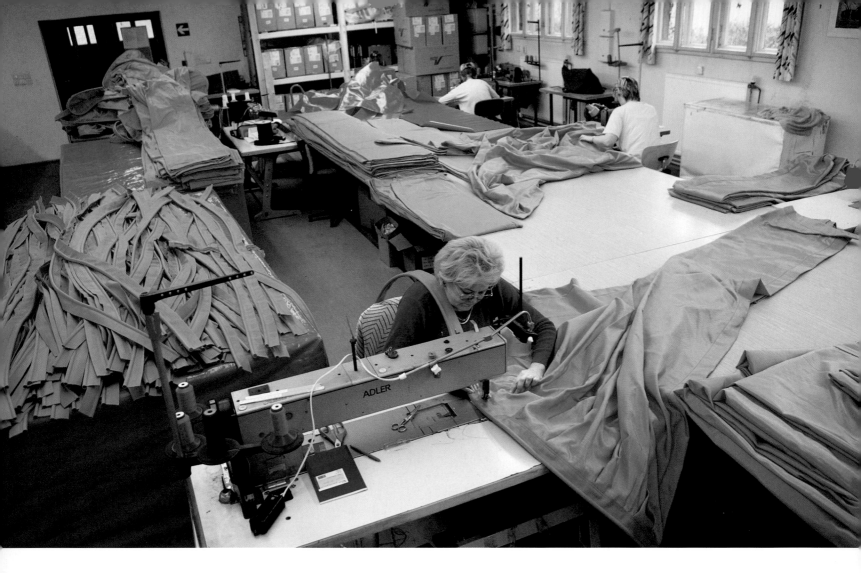

At Bieri-Zeltaplan in Taucha, Germany, Maria Lehmann joins the fold of a
sewn panel to the "bolt rope" (a piece of it is on her shoulder). At the Queens
assembly plant, the "bolt rope" is inserted into the sail tunnel of the horizontal
vinyl pole. The sewing requires 46 miles (74 km) of hems. Hundreds of
thousands of fabric samples will be distributed, for free, to visitors to *The Gates*.

Opposite:
Andreas Marks and Roland Eilenberger have rolled the sewn fabric panels
around a thick cardboard tube and inserted them into a cocoon, closed with
Velcro, ready for shipment to the assembly plant in Queens, NY, where they
are fitted to the horizontal vinyl pole, ready to be trucked to Central Park in
February 2005.

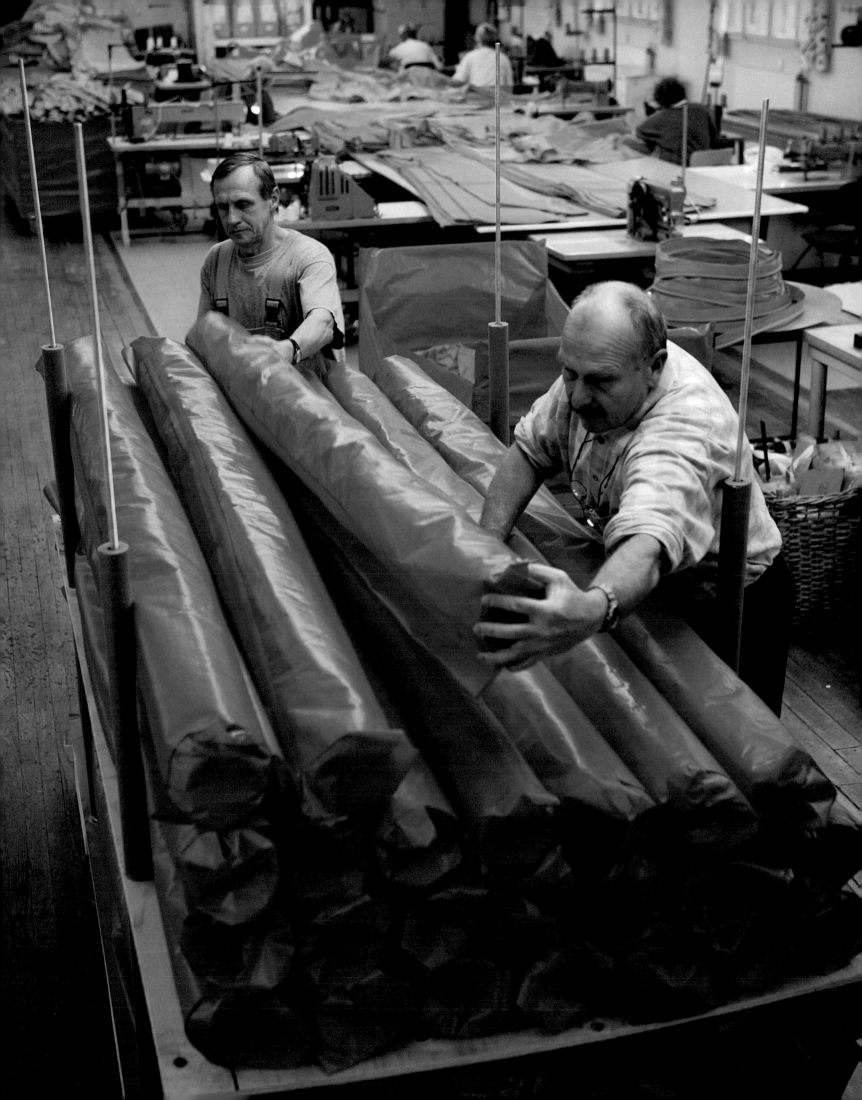

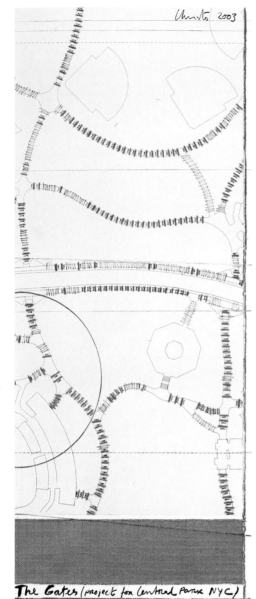

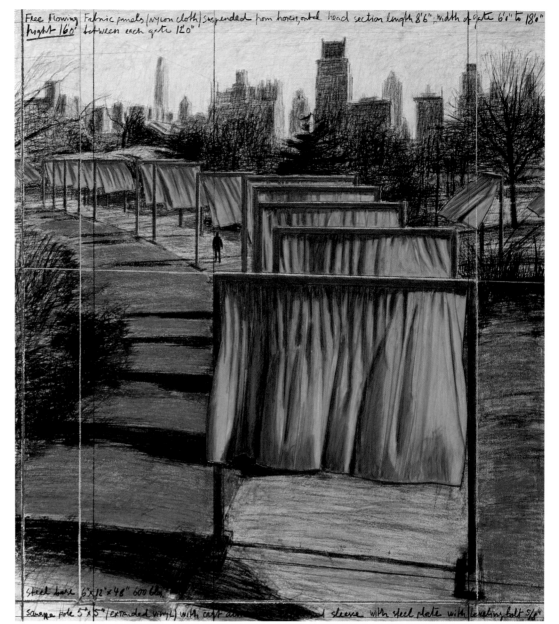

The Gates, Project for Central Park, New York City
Collage, 2003
Pencil, fabric, charcoal, wax crayon, pastel, enamel paint, map and fabric sample
In two parts: 77.5 x 30.5 cm and 77.5 x 66.7 cm
Collection: The artists, "The Gates, Documentation Exhibition, 1979–2005"

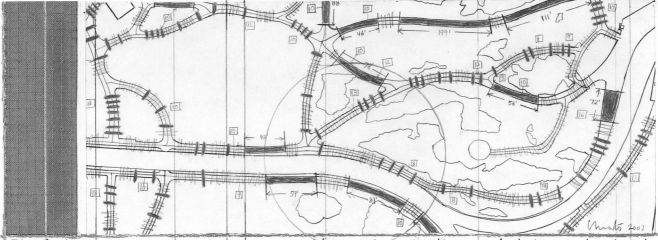

The Gates (Project for Central Park, New York City) Central Park South, 5th. Avenue, Central Park West, West 110 st.

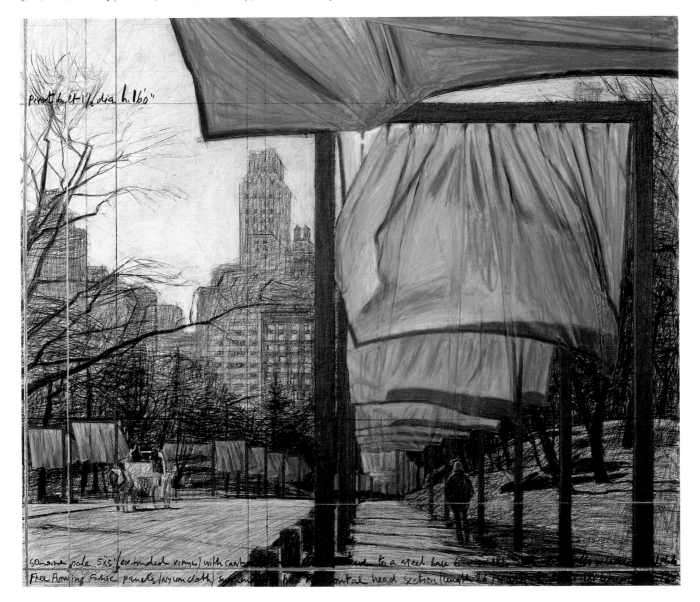

The Gates, Project for Central Park, New York City
Collage, 2003
Pencil, fabric, charcoal, wax crayon, pastel, enamel paint, hand-drawn map, fabric sample and tape
In two parts: 30.5 x 77.5 cm and 66.7 x 77.5 cm
Private collection, Frankfurt/Main, Germany

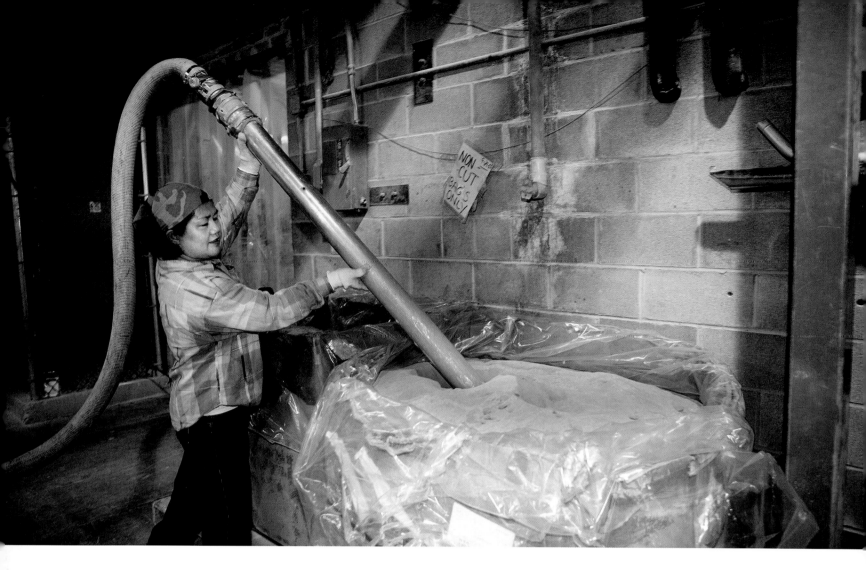

At the North American Profiles Group plant in Holmes, NY, outside of Poughkeepsie, the 5 x 5 inch (12.7 x 12.7 cm) wide vinyl poles are being extruded, non-stop, 24 hours a day, seven days a week. Ms. Jade Wu, machine operator, plunges the end of the vacuum hose into the PVC compound powder, leading to the extruder that will process the material, heating it to 375 degrees (190° C) as it is forced through the extrusion die.

Opposite, top:
Brad Porter, assistant production manager, and Nicholas Mongelli, maintenance manager, supervise the extruder as the vinyl is pulled into the calibrator where the material is sized and cooled, using vacuum and chilled water.

Opposite:
It then comes out as a pole with the "keyhole" (sail tunnel) designed for insertion of the "bolt rope" at the top of the horizontal part of the fabric panel. The lengths are cut automatically, according to the various requirements dictated by the width of the walkways. Weekly truck loads delivered a total of 60 miles (96.5 km) of vinyl for the 22,500 poles to *The Gates* assembly plant in Queens, NY.

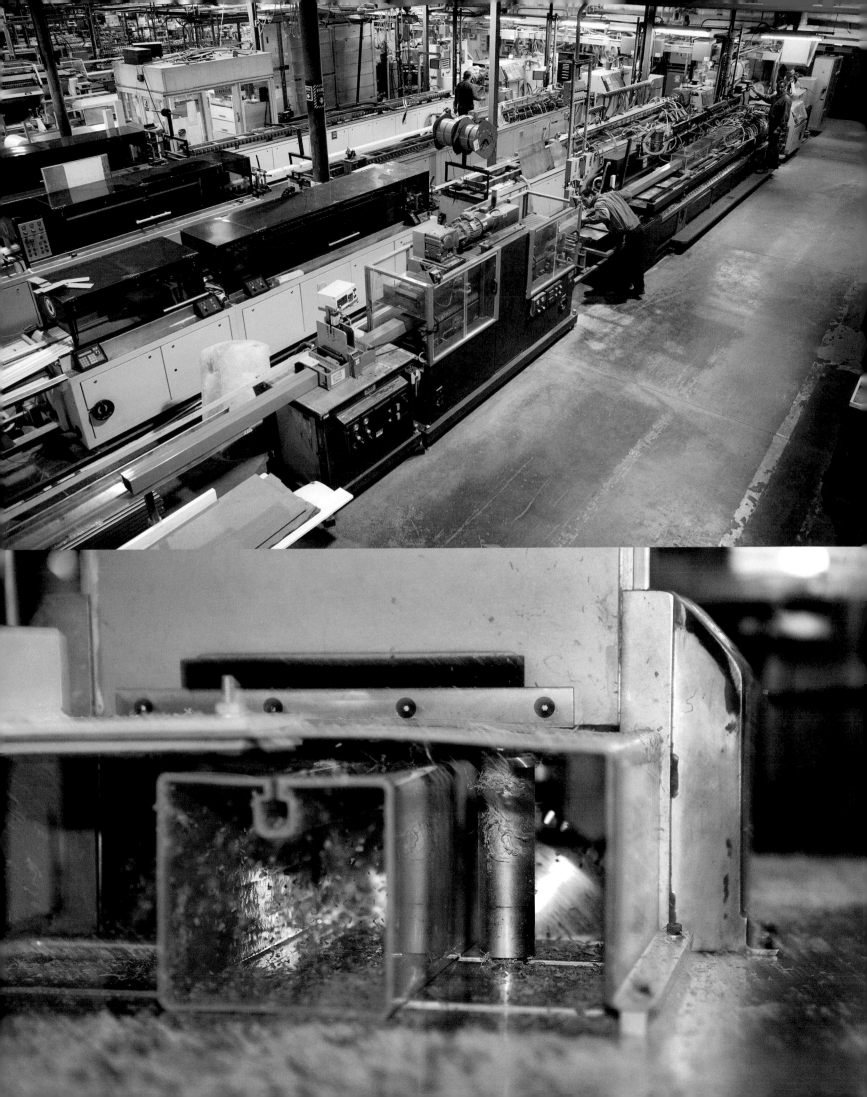

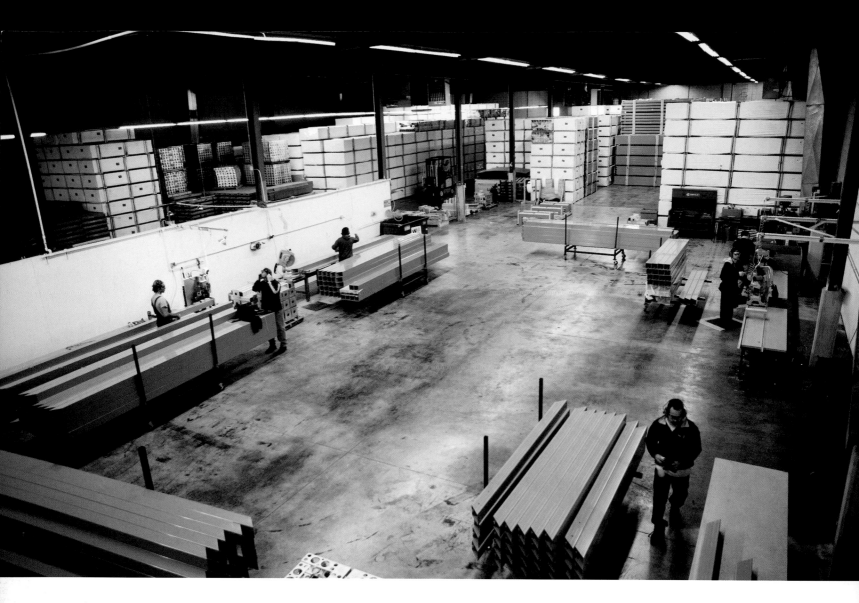

Materials are delivered weekly from the seven United States manufacturers to the 25,000 square feet (2,250 m²) assembly plant (above) and to the storage in Queens, NY. Vince Davenport, chief engineer and director of construction and Jonita Davenport, project director, lead a team of workers through four different work stations to complete the sawing, drilling and bolting operations for the various components of *The Gates*.

Opposite, top:
Ramon DeRosa (on the right) and John Freidhoff insert the aluminum base sleeve into a vinyl vertical pole. Four half-inch (1.27 cm) holes are then drilled simultaneously into the vinyl pole and the aluminum base sleeve by a custom designed 4-gang drill.

Some of the materials
5,290 US tons of steel (4,799 metric tons) for the 15,000 steel bases.
60 miles (96.5 km) of vinyl poles.
15,000 cast aluminum upper corner sleeves.
15,000 base anchor sleeves.
15,000 steel leveling plates.
165,000 bolts and self-locking nuts.
1,092,200 square feet (98,298 square meters) of rip-stop nylon fabric.

Opposite:
Some of the 15,000 base anchor sleeves have already been inserted and bolted into the lower part of the vertical vinyl poles at the Queens, NY, assembly plant. Curt Eckman, warehouse manager, Keir Eliasoph and Steve Tomlinson crate the vinyl poles in preparation for delivery to Central Park in February, 2005.

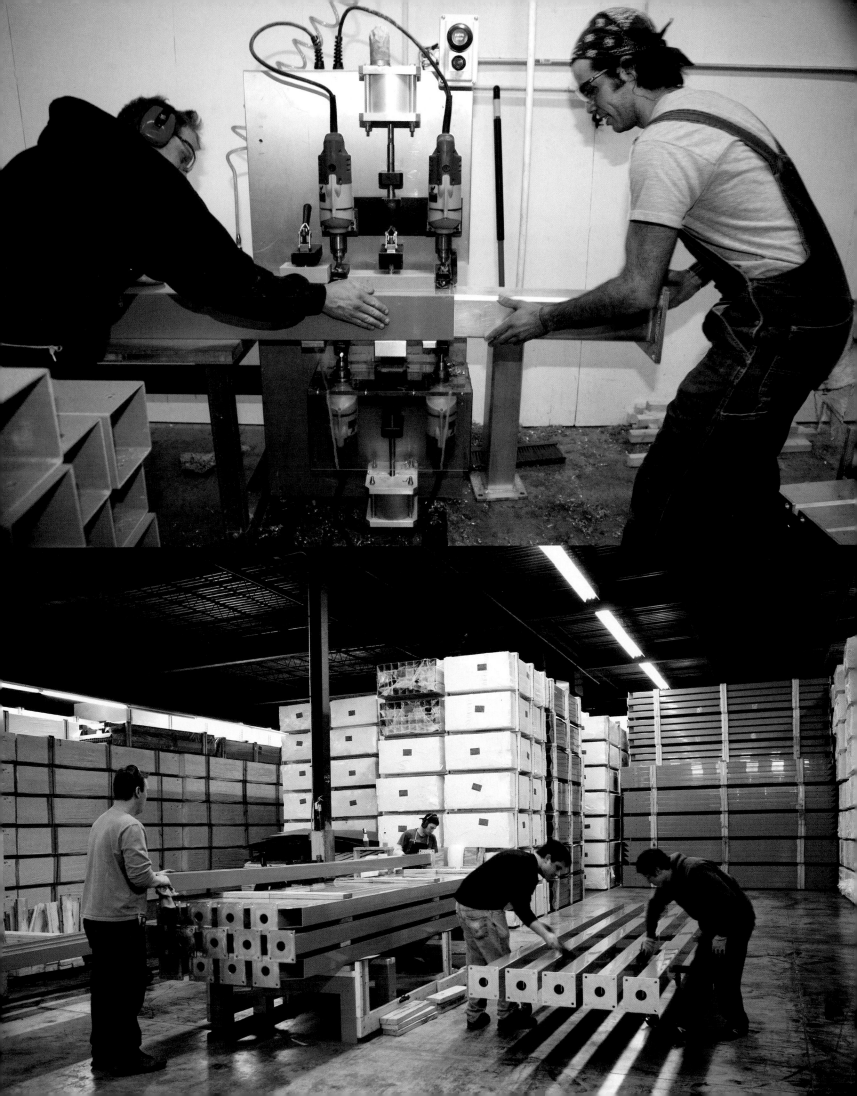

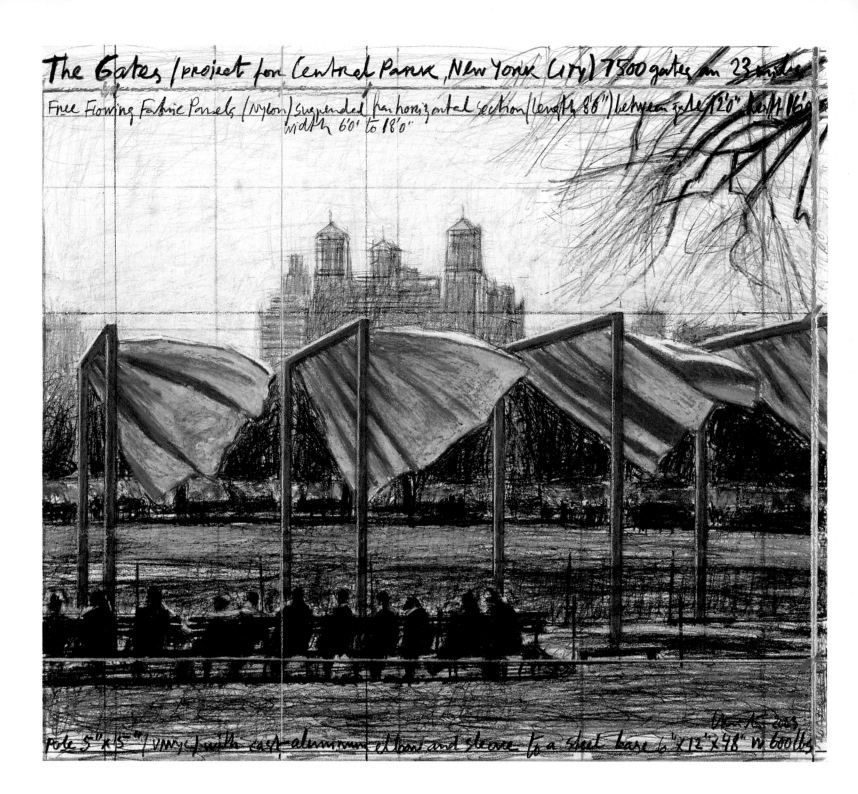

The Gates, Project for Central Park, New York City
Drawing, 2003
Pencil, pastel, charcoal and wax crayon
35.2 x 38.7 cm
Private collection, New York

The Gates, Project for Central Park, New York City
Drawing, 2004
Pencil, charcoal, pastel, wax crayon, enamel paint, fabric sample,
hand-drawn map, technical data and tape
In two parts: 244 x 38 cm and 244 x 106.6 cm

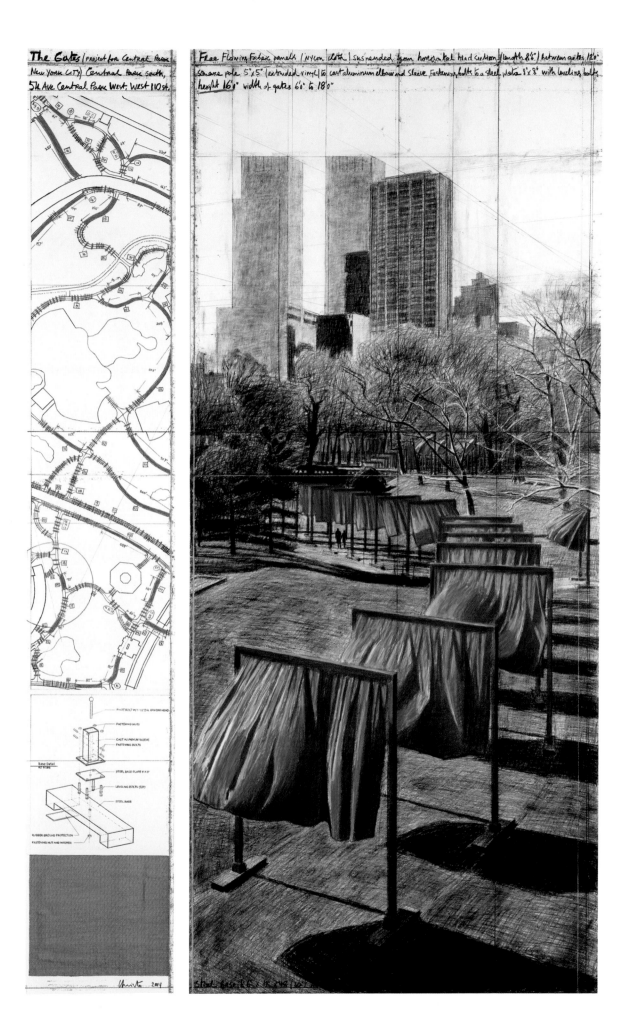

The Gates (project for Central Park
New York City) Central Park South,
5th Ave Central Park West, West 110 St.

Free Flowing Fabric panels (Nylon cloth) suspended from horizontal head section (length 8'6") between gates 12'0"
square pole 5"x5" (extruded vinyl) to cast aluminium elbow and sleeve. Fastening bolts to a steel plate 8'x 8' with leveling bolts
height 16'0" width of gates 6'0" to 18'0"

Steel Flowing Fabric panels (Nylon cloth)
height 16'0" width of gates 6'0" to 18'0"

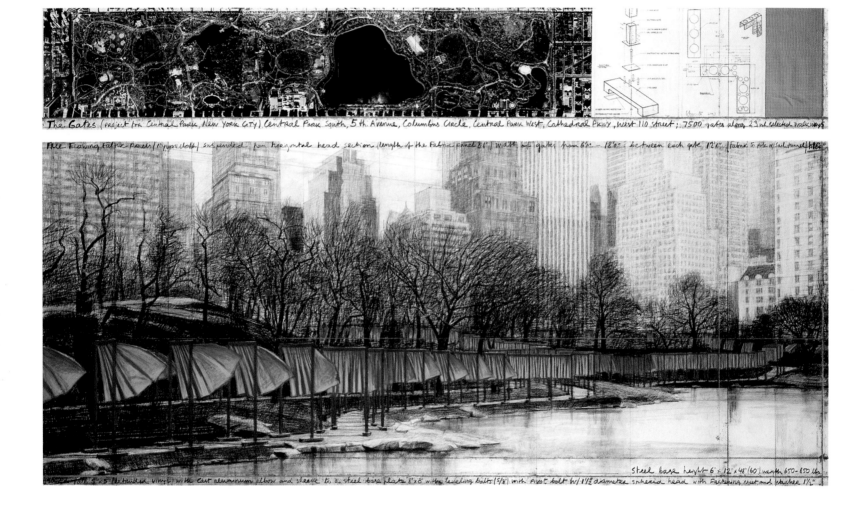

The Gates (project for Central Park, New York City) Central Park South, 5th Avenue, Columbus Circle, Central Park West, Cathedral Pkwy, West 110 Street; 7500 gates along 23 mi selected walkways

Free Flowing Fabric panels / Nylon cloth / suspended from horizontal head section (length of the Fabric panel 8'6") Width of gates from 6'0" - 18'0"; between each gate 12'0"; fabric to side of walkway 1'6"

steel base height 6" x 12 x 48" (60") weight 650-850 lbs

The Gates, Project for Central Park, New York City
Drawing, 2003
Pencil, charcoal, pastel, wax crayon, enamel paint, fabric sample,
aerial photograph, hand-drawn technical data and tape
In two parts: 38 x 244 cm and 106.6 x 244 cm
*Collection Whitney Museum, New York. Purchase, with funds from Melva
Bucksbaum and Raymond L. Learsky*

The Gates, Project for Central Park, New York City
Drawing, 2003
Pencil, charcoal, pastel, wax crayon, enamel paint, fabric sample, hand-drawn map, technical data and tape
In two parts: 244 x 38 cm and 244 x 106.6 cm

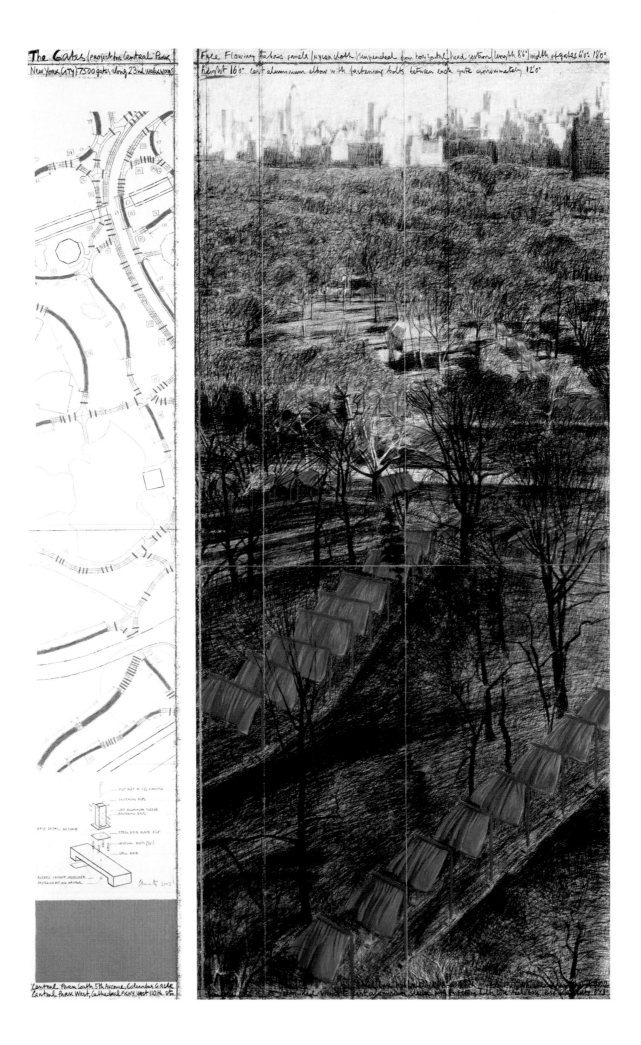

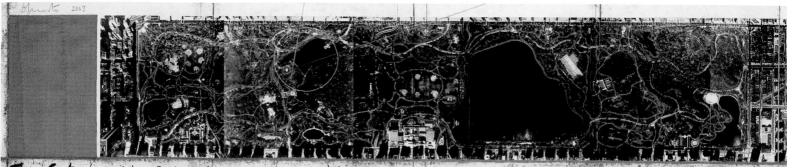

The Gates (project for Central Park, New York City) Central Park South, 5th Avenue, Columbus Circle, Central Park West, West 110th Street

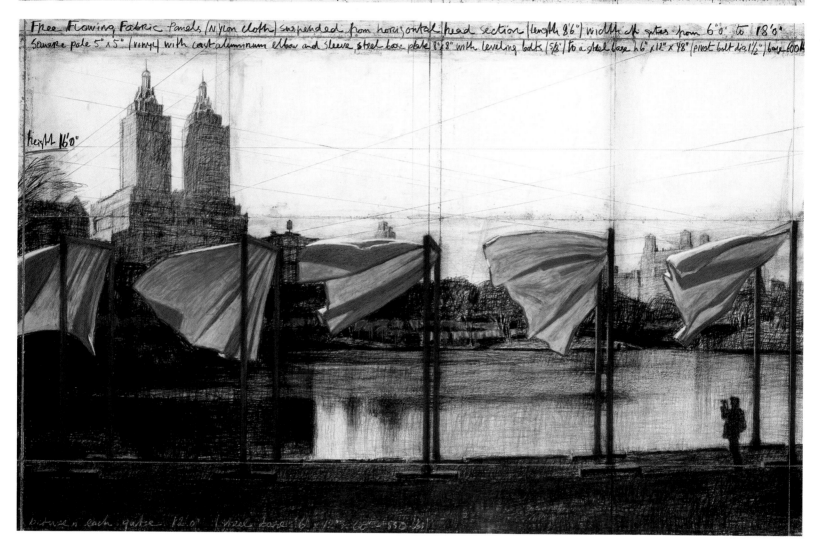

Free Flowing Fabric Panels (Nylon cloth) suspended from horizontal head section (length 86") width of gates from 6'0" to 18'0"
Square pole 5" x 5" (vinyl) with cast aluminum elbow and sleeve, steel base plate 8"x8" with leveling bolts (5/8) to a steel base 6" x 12" x 48" (pivot bolt dia 1½") base 600 lb

height 16'0"

distance in each gate 12'0" (steel base 6" x 12" x 60" = 850 lbs)

The Gates, Project for Central Park, New York City
Drawing, 2003
Pencil, charcoal, pastel, wax crayon, aerial photograph and fabric sample
In two parts: 38 x 165 cm and 106.6 x 165 cm

The Gates, Project for Central Park, New York City
Collage, 2004
Pencil, fabric, charcoal, wax crayon, pastel, enamel paint,
hand-drawn map, tape and fabric sample
In two parts: 30.5 x 77.5 cm and 66.7 x 77.5 cm
Private collection, Sweden

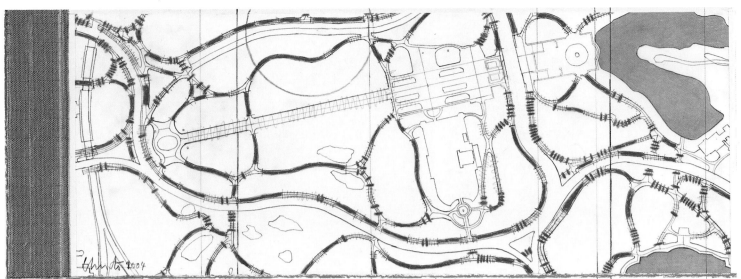

The Gates (project for Central Park, New York City) Central Park South, 5th Avenue, Central Park West, West 110th Street

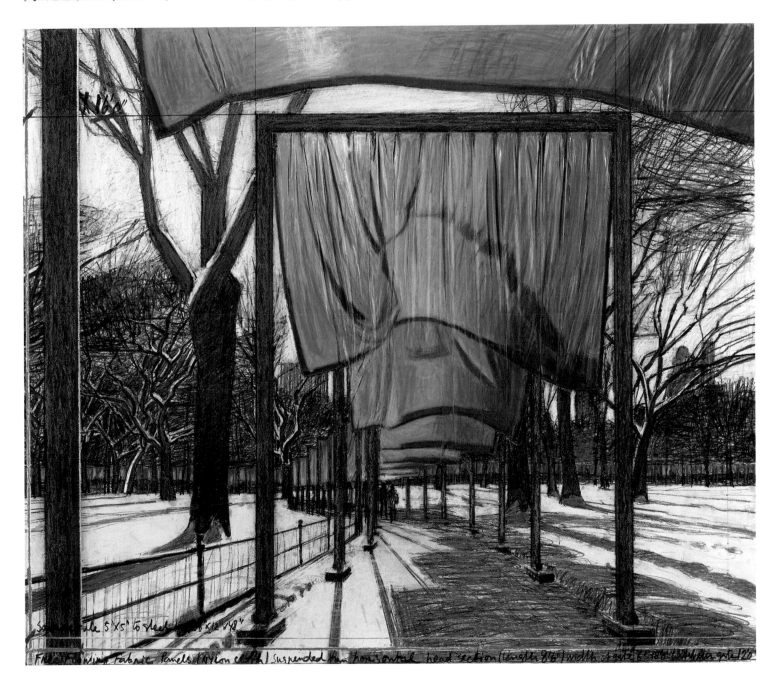

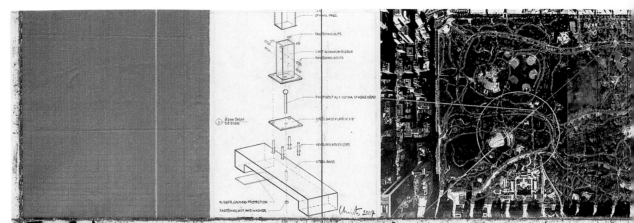

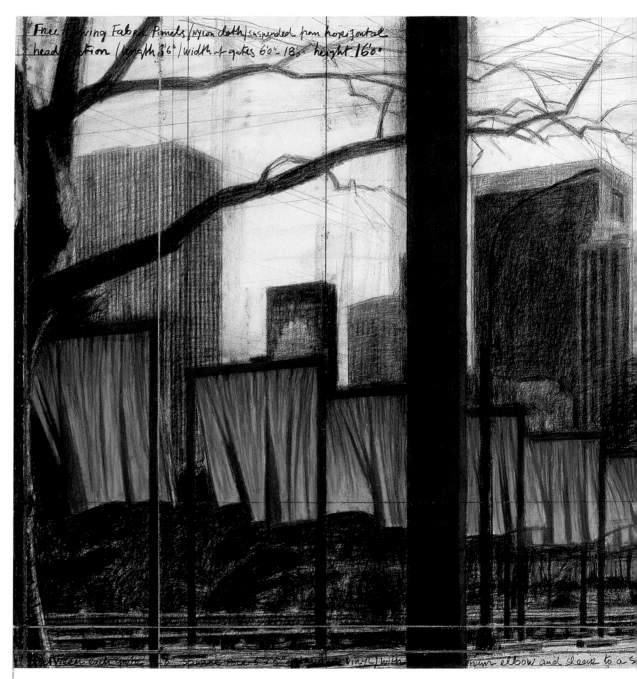

The Gates, Project for Central Park, New York City
Drawing, 2004
Pencil, charcoal, pastel, wax crayon, fabric sample, aerial photograph and hand-drawn technical data
In two parts: 38 x 244 cm and 106.6 x 244 cm
Private collection, Biella, Italy

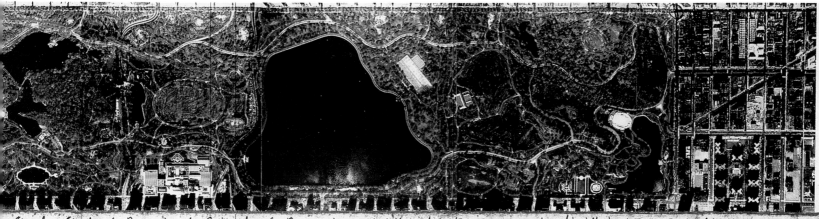

s Circle, Central Park West, Cathedral Pkwy, West 110th Street, 7500 gates (h. 16'0") along 23 ml selected walkways

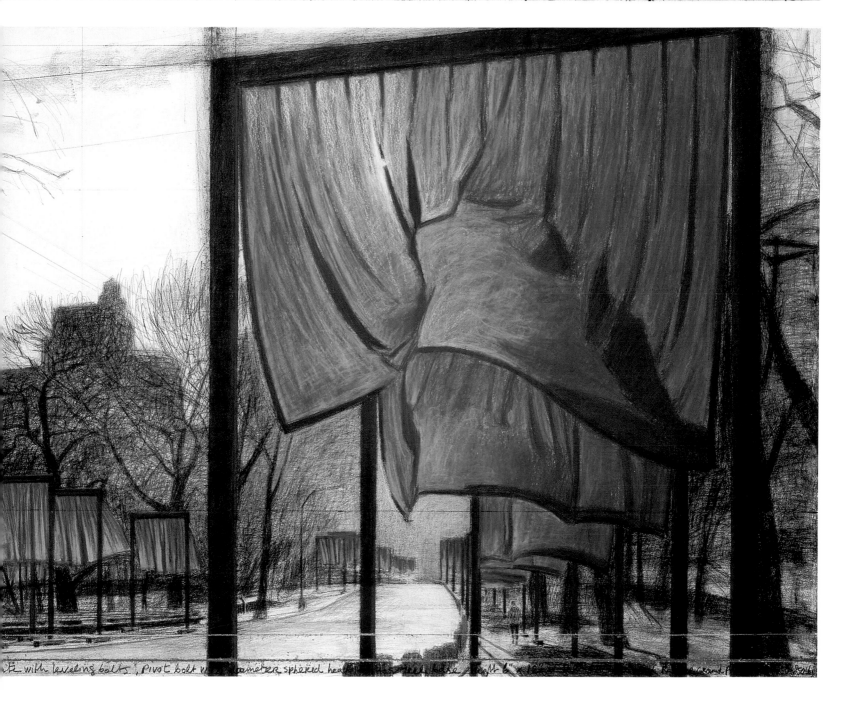

ft with leveling bolts, pivot bolt w... diameter sphered head... ...height 6"...

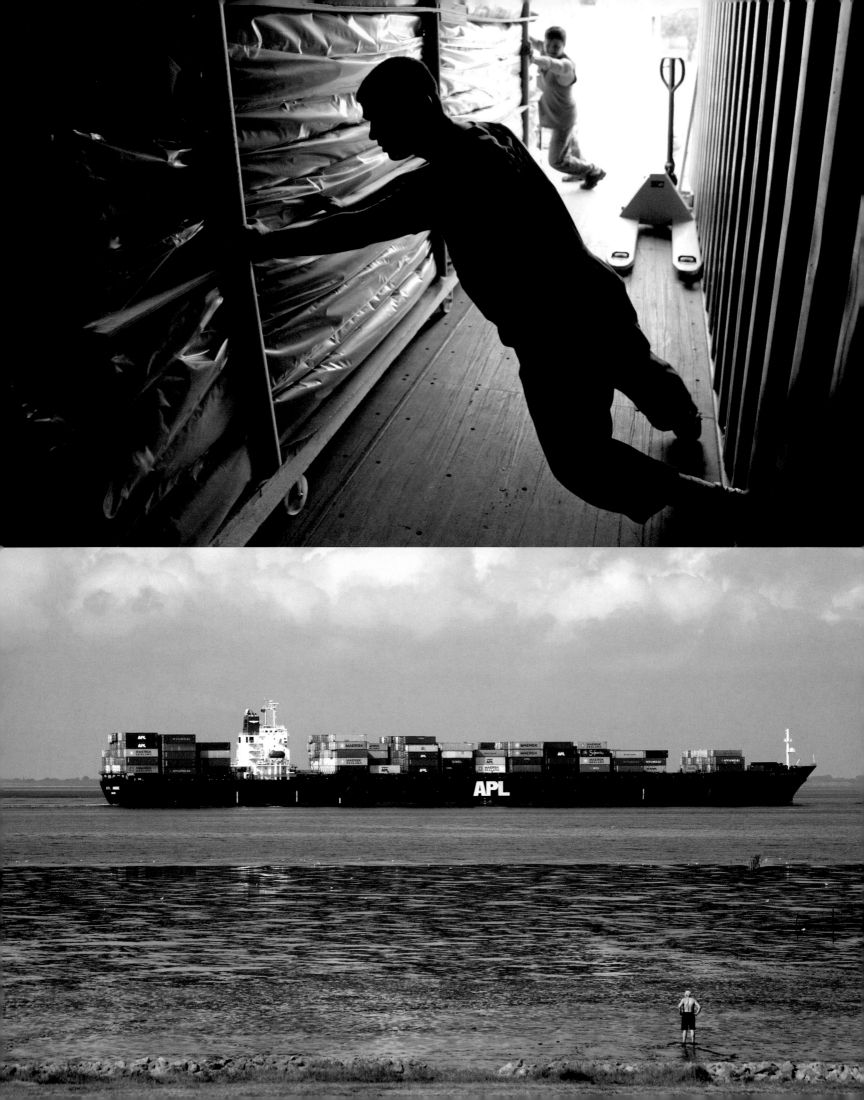

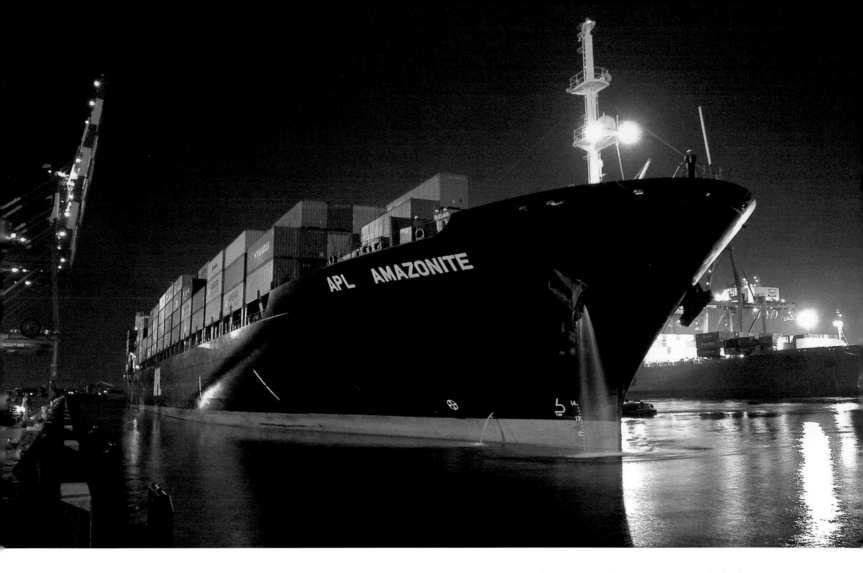

Opposite, top:
At the sewing plant in Taucha, 100 fabric panels, in their cocoons, are stacked on rolling pallets ready to be loaded into a container. For the 7,500 fabric panels a total of 10 containers were shipped to the assembly plant in Queens, New York.

On August 10, 2004, the container ship APL Amazonite docked at 4.12 AM at the container terminal in Elisabeth, New Jersey, New York Harbor. The containers were trucked to the Queens, NY, assembly plant, where the rolled fabric panels, in their cocoon, were fitted to the top horizontal vinyl poles.

Opposite:
One of the 10 container ships, the APL Amazonite left the harbor in Bremer-haven, Germany, on August 2, 2004, at 11.30 AM, heading for the USA.

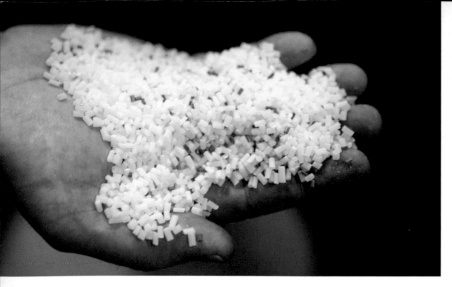

At the LMT-Mercer Group in Lawrenceville, New Jersey, polystyrene thermo-plastic pellets, with 3% saffron color concentrate, are heated to 440 degrees (226° C) in a Toshiba 250 ton injection molding machine. 13,390 pounds (6,073 kg) of pellets are required to produce 15,000 base plate covers.

Eric Schwarz, lead processor, is removing a solidified, completed base plate cover out of the injection mold. Each one of the 15,000 base plate covers is individually molded and inspected.

Opposite:
Jim Fattori, Vice President of Engineering, inspects one of the base plate covers. These are used during the installation in Central Park to conceal the leveling plates assembly of the gates where the vertical poles are bolted to the steel base-weights.

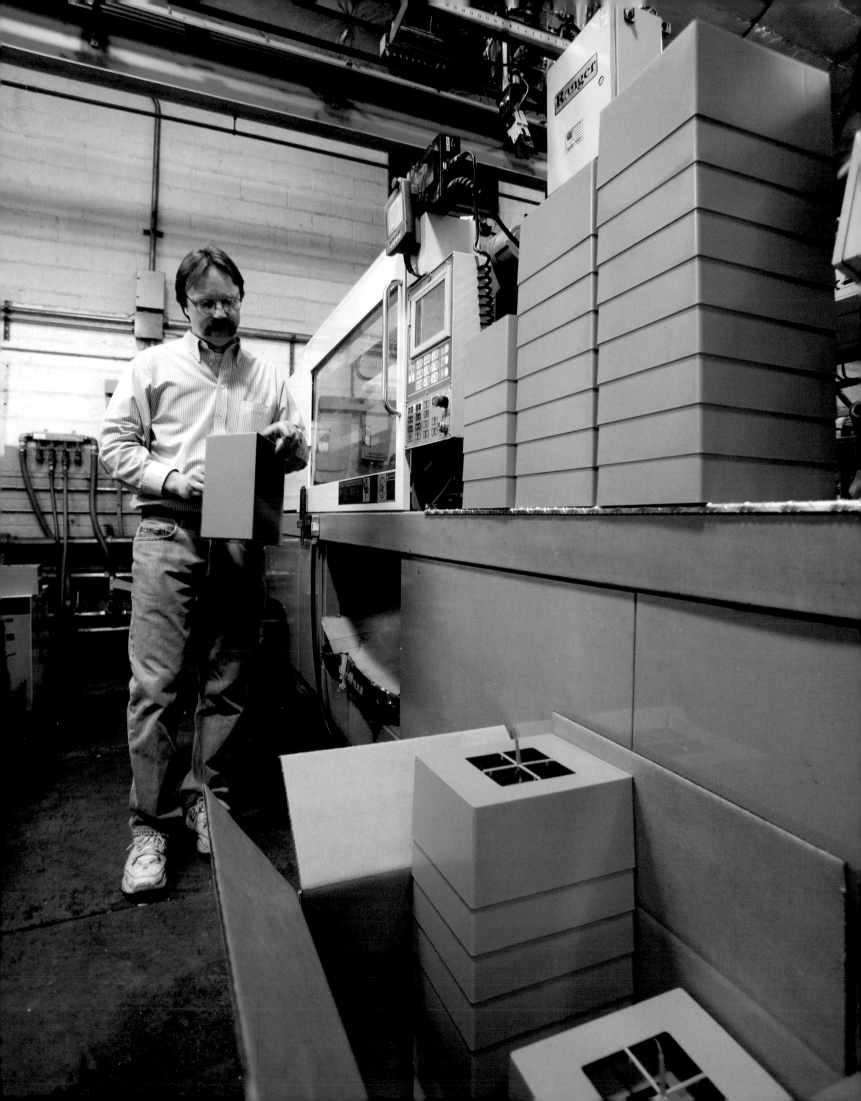

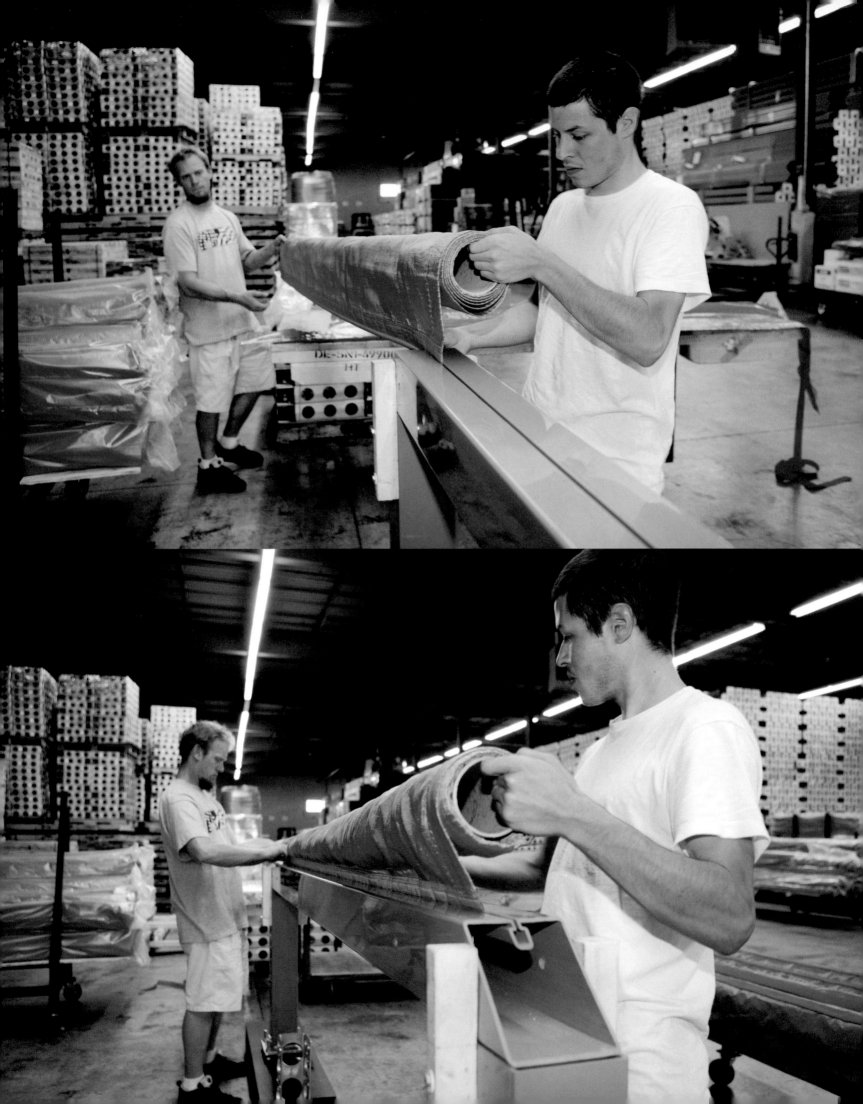

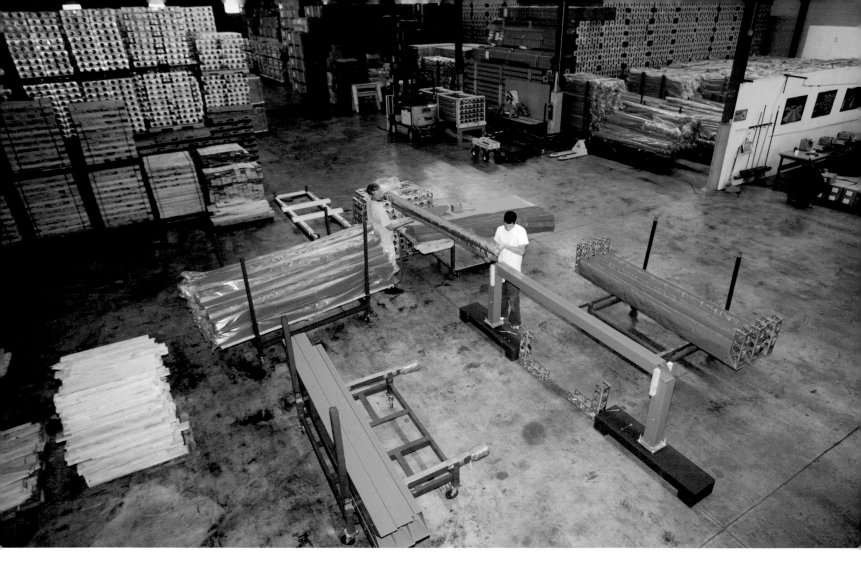

At the assembly plant in Queens, after having opened the cocoon in which the fabric panel had been shipped, Johnny Freidhoff and Steven Tomlinson insert the "bolt rope" sewn at the top of the fabric panel, into the "sail tunnel" of the horizontal pole.

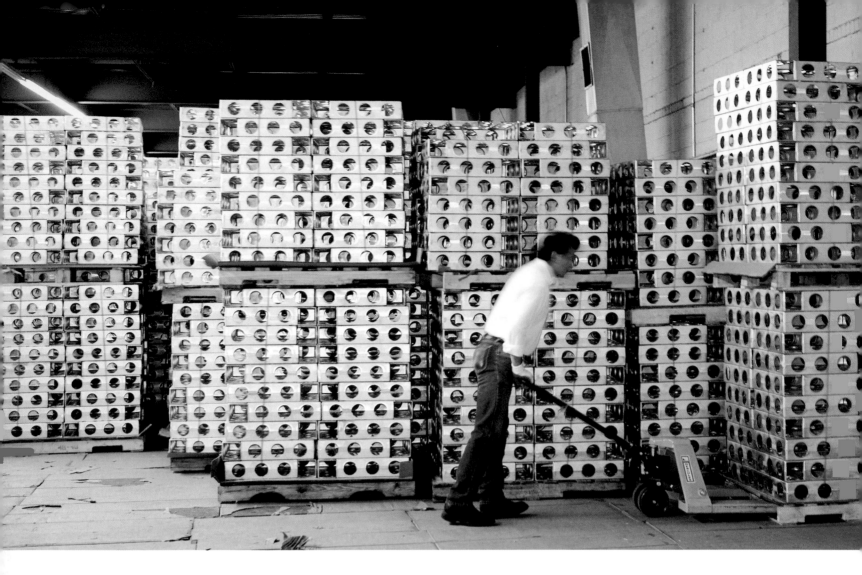

Oscar Ayaqui uses a pallet jack to move a stack of aluminum corner sleeves which secures the vertical poles to the top horizontal poles.

Opposite, top:
After the top of the fabric panel has been secured inside the "sail tunnel" of the horizontal vinyl pole, Steven Tomlinson inserts one side of the angled aluminum corner sleeve into the 5 inch (12.5 cm) pole.

Opposite:
Johnny Freidhoff and Steven Tomlinson place and close the cocoon around the horizontal pole. The finished assembly (horizontal pole, fabric in cocoon and 2 aluminum corners) is now ready to be shipped to Central Park.

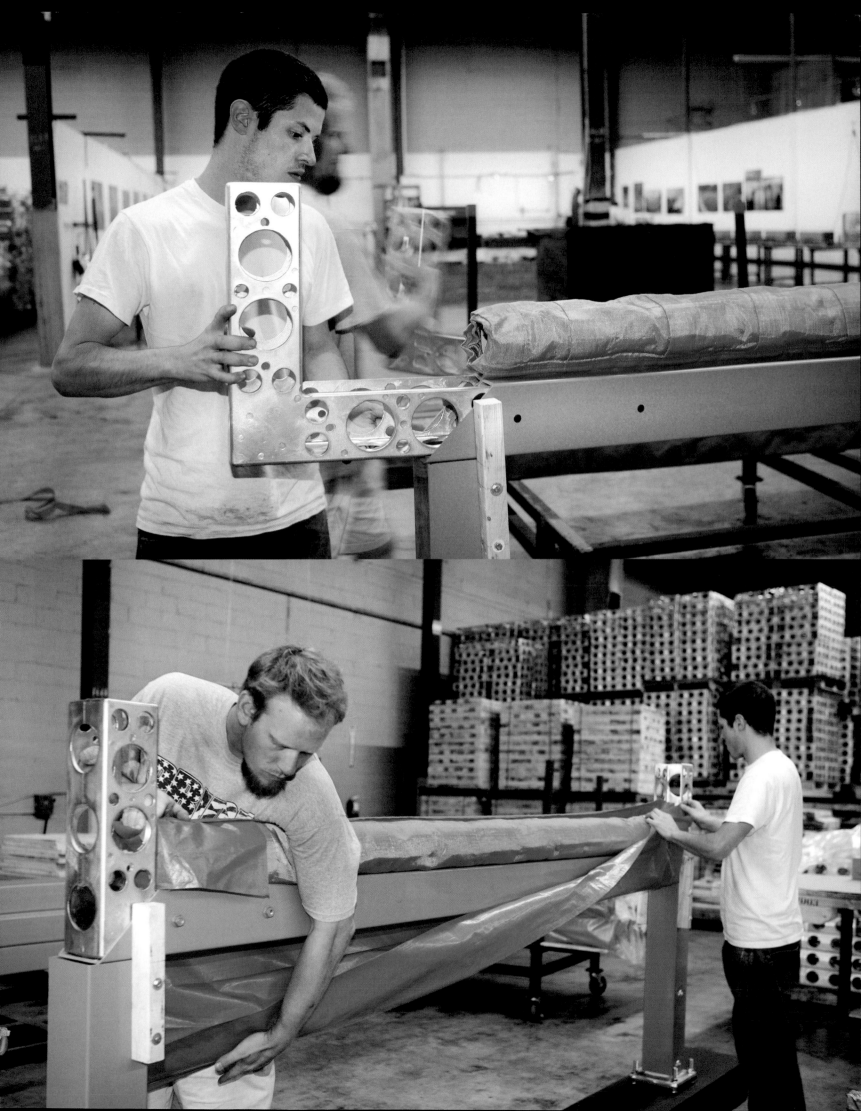

The 15,000 steel leveling plates, each 8 x 8 inches (20 x 20 cm), with four carriage bolts 3 1/2 x 5/8 inches (9 x 1.4 cm) are inspected by Johnny Freidhoff and Steven Tomlinson. (They use a special attachment, on an electric drill, designed to fit the head of a carriage bolt, to ensure proper threading into the leveling plate.) The leveling plates with carriage bolts are packaged in boxes of 6 (for 3 gates). Each box weighs 50 pounds (22.7 kg).

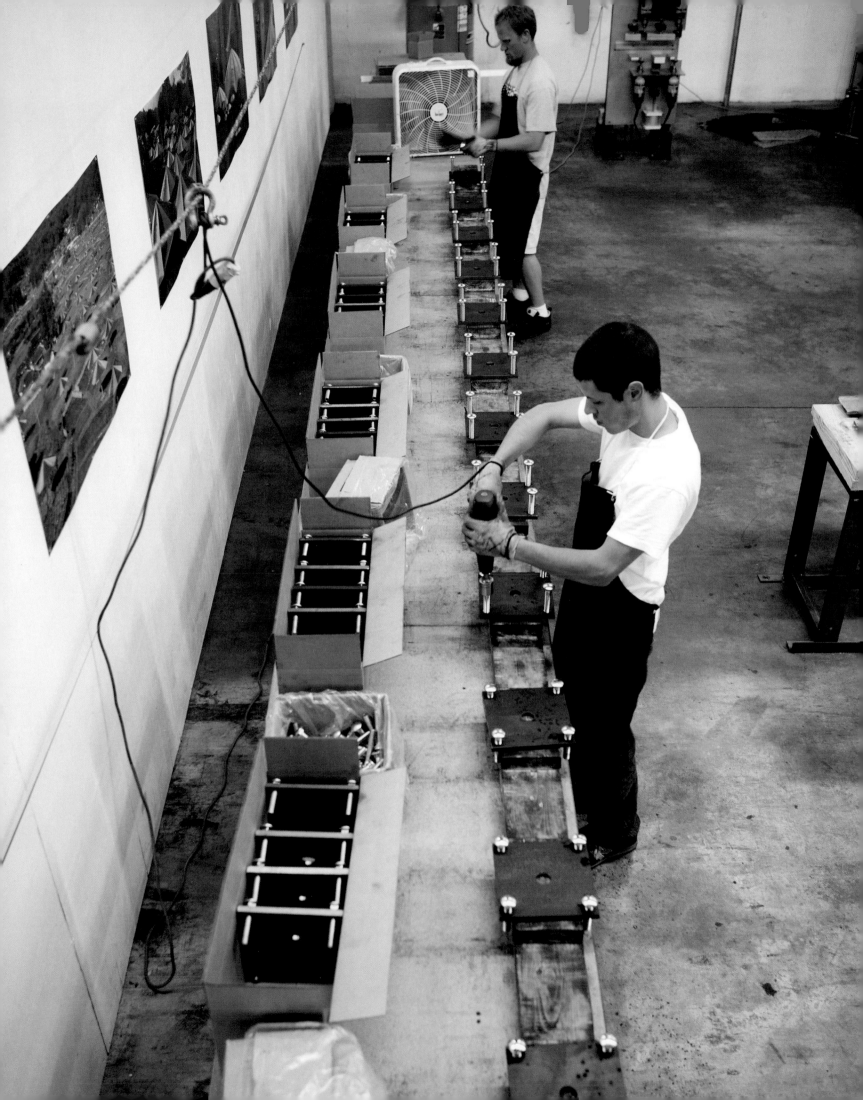

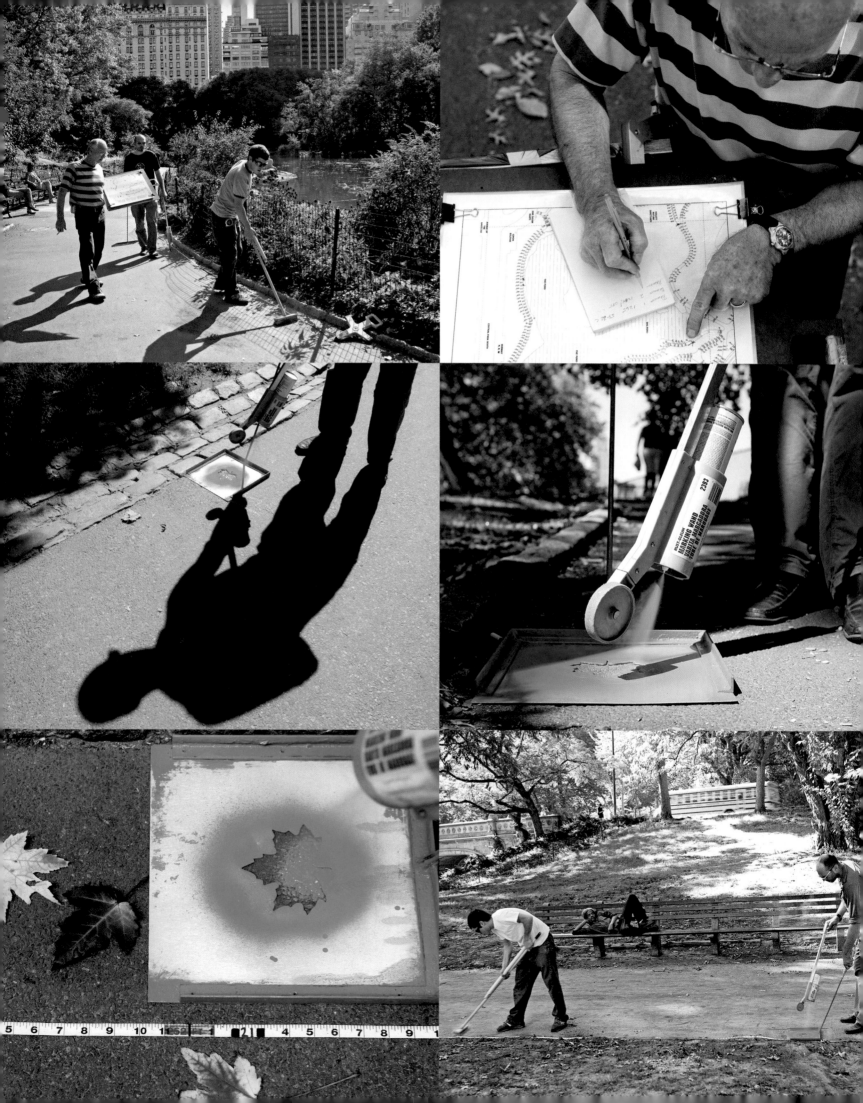

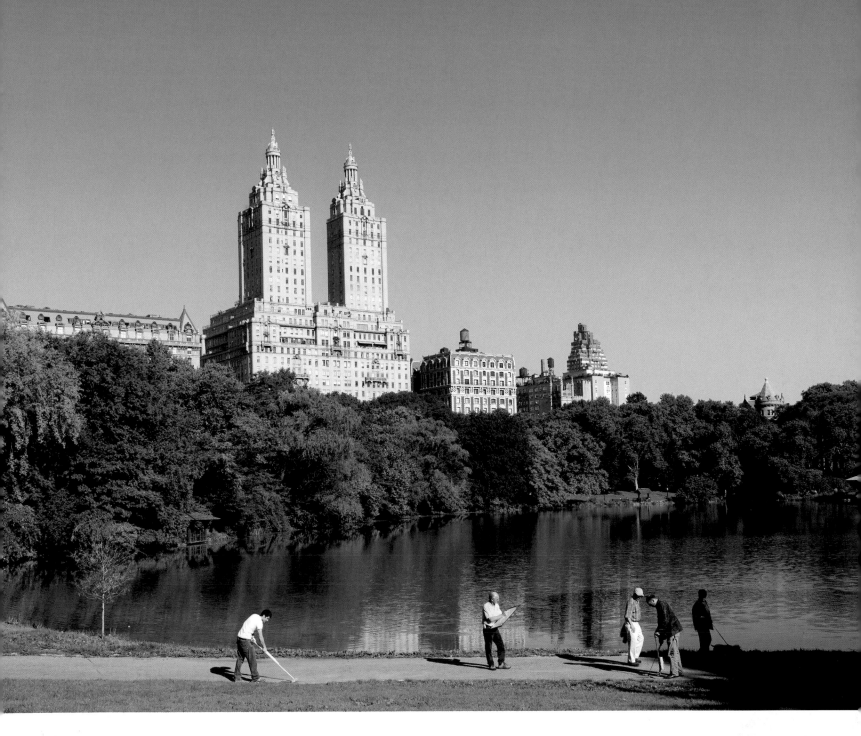

Clockwise:

During September and October 2004, Vince Davenport, Vladimir Yavachev and Steven Tomlinson marked the locations of the 7,500 gates on the hard surface of the 23 miles (37 km) walkways in Central Park. Professional workers start installing the 15,000 steel bases on January 3, 2005.

Vince Davenport records on his two year old maps the many corrections of the locations of the gates. Because the Parks Department cut some low branches, 315 gates were added, while nature made many low branches grow above the walkways, and 361 gate's locations were removed.

Using a marking wand Vladimir Yavachev holds a specially designed spray can of green paint to mark each gate location.

A stencil made by Vince Davenport, in the shape of a maple leaf, indicates the gate's location. The green maple leaf is the logo of the Parks Department throughout the City's five boroughs.

Steven Tomlinson sweeps the walkway so that the green paint will adhere to the asphalt, while Vladimir Yavachev follows with the spray can.

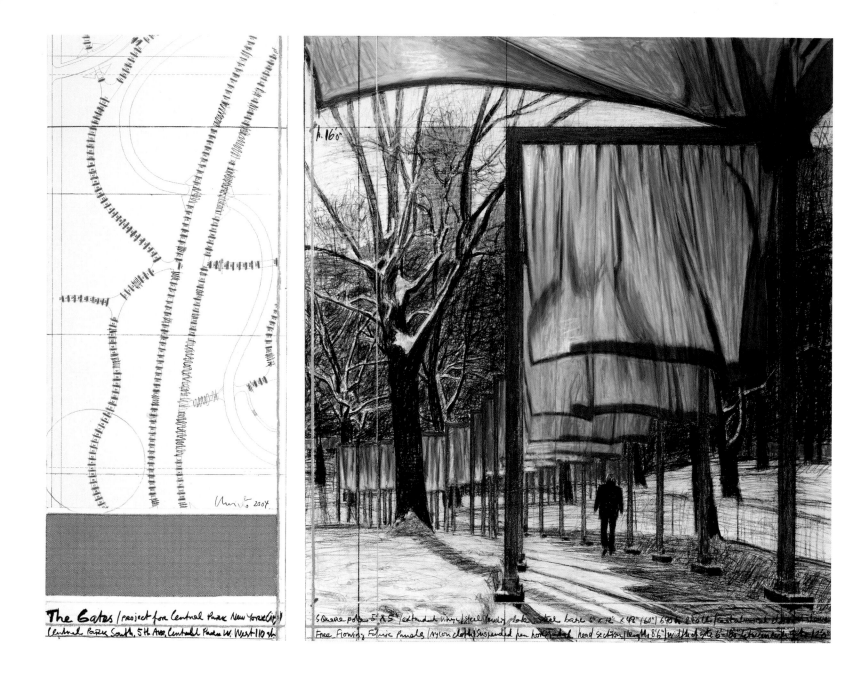

The Gates, Project for Central Park, New York City
Collage, 2004
Pencil, fabric, wax crayon, charcoal, enamel paint, pastel, map and fabric sample
In two parts: 77.5 x 30.5 cm and 77.5 x 66.7 cm

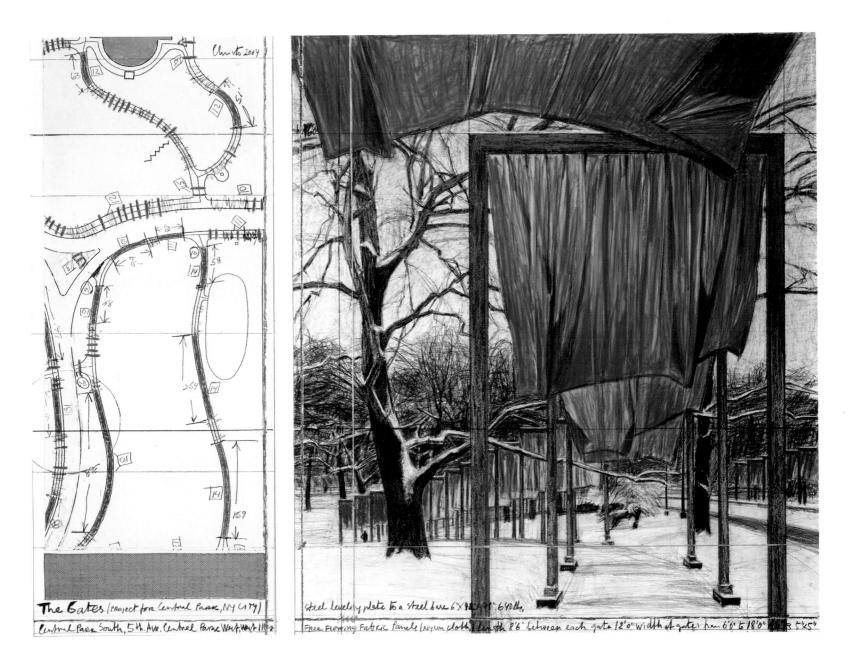

The Gates, Project for Central Park, New York City
Collage, 2004
Pencil, fabric, wax crayon, charcoal, enamel paint, pastel, map and fabric sample
In two parts: 77.5 x 30.5 cm and 77.5 x 66.7 cm

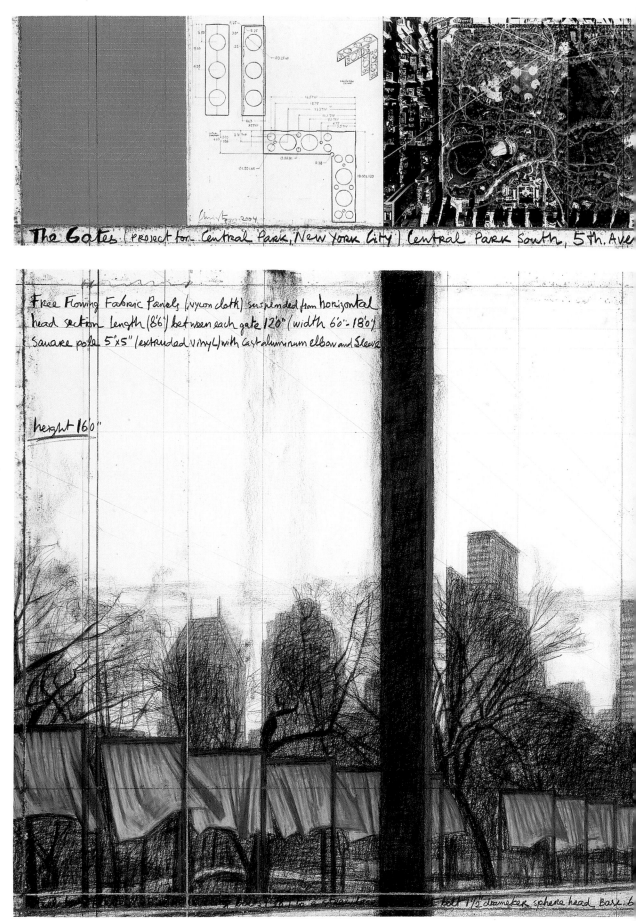

The Gates (project for Central Park, New York City) Central Park South, 5th. Ave

Free Flowing Fabric Panels (nylon cloth) suspended from horizontal head section length (8'6") between each gate 12'0" (width 6'0"-18'0") Square pole 5"x5" (extruded vinyl) with cast aluminum elbow and sleeve

height 16'0"

The Gates, Project for Central Park, New York City
Drawing, 2004
Pencil, charcoal, pastel, wax crayon, fabric sample, aerial photograph, tape and hand-drawn technical data
In two parts: 38 x 244 cm and 106.6 x 244 cm

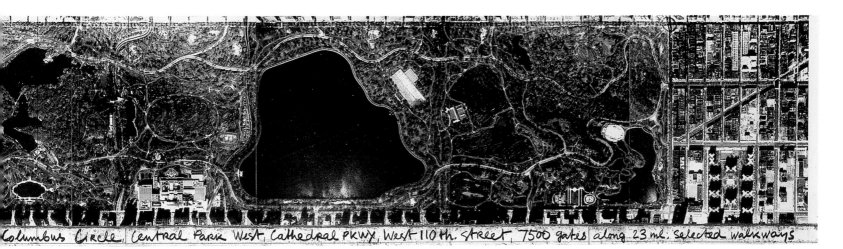

Columbus Circle, Central Park West, Cathedral Pkwy, West 110th. Street, 7500 gates along 23 ml. selected walkways

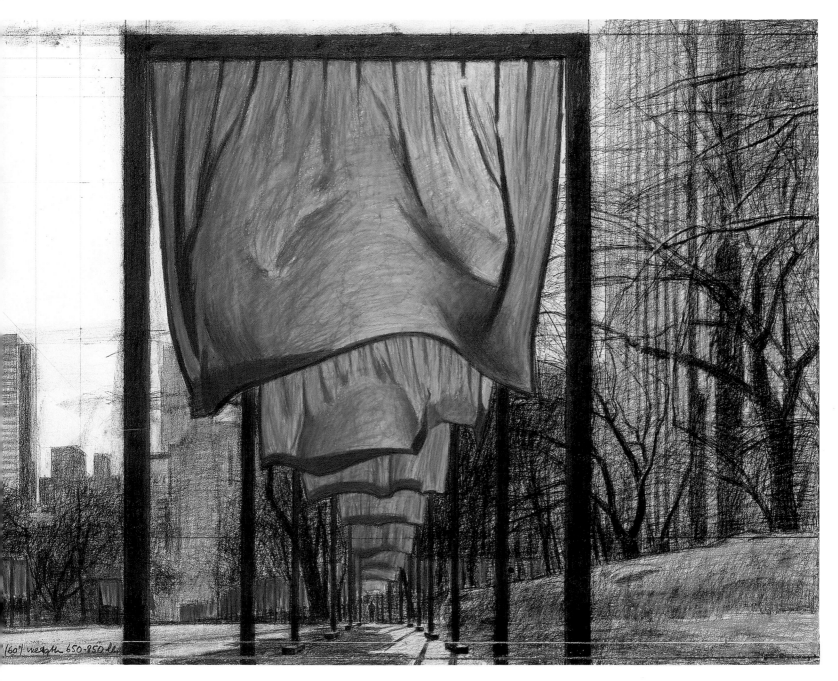

(60") height 650-850 lb